WATERCOLOR
PAINTING
ON LOCATION

WATERCOLOR PAINTING ON LOCATION

How to create a "portable studio" and capture
the unique qualities of the outdoors in your paintings.

by El Meyer

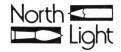

Published by North Light, an imprint of Writer's Digest Books, 9933 Alliance Road, Cincinnati, Ohio 45242.

Manufactured in U.S.A.
First Edition

Library of Congress Cataloging in Publication Data

Meyer, El.
 Watercolor painting on location.

 Bibliography: p.
 Includes index.
 1. Water-color painting—Technique. I. Title.
ND2420.M487 1984 751.42′2 83-25449
ISBN 0-89134-068-8

Dedicated to my wife, Hazel, and to my children, Gerald, Roberta, and Laurel.

A debt of gratitude is owed to the owners of all paintings reproduced in this book.

Contents

The Search

In a creative search for new and vigorous expressive means, the watercolorist explores many avenues, not the least of which is painting on location, which brings with it meaningful rewards. Nature's teachings have, throughout history, led the way for artists to reach a fuller expression of their creative powers.

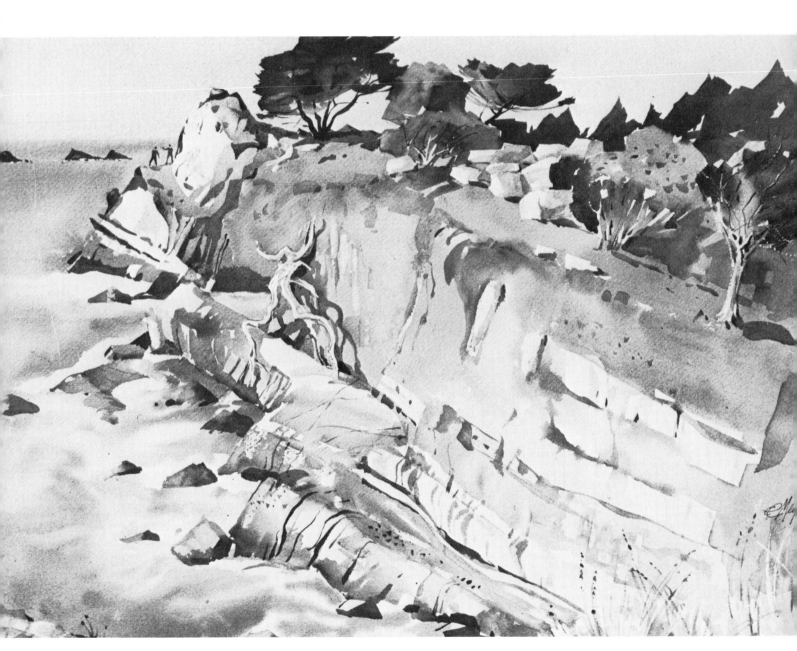

Figure A-1.
Whale Watching, California Coast, 22x30 inches.

Introduction

Countless valuable words have been written about the methods and techniques of watercolor painting, yet most of these seem to be momentarily forgotten when we come face to face with that big blank sheet of watercolor paper. Perhaps it is because we are uninspired, or we are unable to draw fresh new images from within our mind. Then, too, we are inclined to measure our efforts against the work of advanced painters and professionals who have spent many years in developing a personal style and means of expression. The shifting trends and innovations in the art world cause further bewilderment and dismay.

A newfound enthusiasm and great rewards can be generated by going directly to nature. All of our painting knowledge suddenly comes into focus when we observe nature's textures, patterns, and shapes. It only remains for us to select those things that will help us structure an exciting painting and to reject those that diminish our personal vision.

The exhilaration of confronting nature in its various moods may cause us to rush in too quickly with our paints without due concern for the medium's inherent virtues and potentials. Midway into our washes we become aware that some of the elements in our composition are not well thought out, or are not as expressive as they could be. To correct these deficiencies, we start going over clean passages with other colors and values—and there goes the luminosity, one of watercolor's chief virtues.

Other virtues—clarity of tone, exciting color nuances, and transparency of glazes—are often impaired when the artist resorts to tricks to give a superficial effect. While most useful to create surface interest, such devices are meaningless without discipline and attention to underlying principles that enable our picture to grow and evolve into a personal statement.

Whatever idea we wish to express or whatever subject interests us as material for a watercolor, the success of the painting depends on selecting the right values and distributing the shapes effectively. Painting procedures need to be well thought out or we may find ourselves just pushing paint around, hoping something exciting will happen.

It has often been said that we paint best the things we know best and the things we like best. Our environment has much to do with what we like or dislike. I was born and raised on a farm. I still remember the joy I felt as a young boy in Twin Falls, Idaho, watching my father plowing the fields with a team of horses, as cloud shadows chased each other across the landscape. Later, after I moved to California's Sacramento Valley, barns, windmills, farm machinery, and boats became a daily part of my environment. Having also lived in cities the greater part of my life, I am as excited by street scenes and architectural variety as I am by the rural scene. This varied background has brought me into contact with people of many races and professions.

Subjects that have a special appeal for me are waterfronts and coastal scenes. The unique qualities of light and atmospheric effects provide spectacular contrasts or subtlety of values. There is nothing more thrilling and satisfying than painting outdoors, especially on California's north coast, where the subject matter is endlessly diversified and the climate is mild.

My interest in watercolor began in San Francisco shortly after World War II, while I was employed as a graphic artist in the printing and lithography industry. Designing posters and labels brought me in contact with a number of illustrators who were making their mark with exciting watercolors. Seeing their work made me aware of the great potential of the transparent medium. This awareness was heightened by frequent visits to local watercolor shows and art museums, where I discovered a marked difference between watercolors painted in

Figure A-2.
Barns at Point Reyes, 18x24 inches.

The Motif

The selection of a motif has less to do with depicting a particular scene or subject than it has with finding a path that will allow us to bring to light the hidden aspects of design, color, and form.

the studio and those painted on location. The clarity and immediacy of the outdoor painting so fascinated me that I felt a strong need to paint the outdoor scene.

Opportunities to sketch and paint were limited, but I did manage to get out occasionally, usually after working hours. What looked so easy didn't always turn out that way. Fortunately, about this time Eliot O'Hara came to San Francisco and I enrolled in his landscape painting classes. This started an involvement in watercolor painting that continued in the outdoor watercolor workshops of many other well-known artists.

It took me years to gain control of the medium and to develop my way of painting, and I continue to learn more about this fascinating medium every time I go out to paint. By trying different approaches and methods I have discovered many of the techniques that are a part of my painting style.

There is no question that painting a watercolor on location can provide the artist with more inspiration than can be found in any other way. While nature has always been the motivating force for new ideas and subject matter, an increasing number of watercolorists, both students and professionals, are getting out of their studios and into the outdoors, where they can capture a more spontaneous and exciting impression of a place or scene.

Painting on location is a rewarding adventure. To help you *see* and *capture* the essentials of your subjects with boldnesss and directness is the aim of this book. I have included numerous reproductions of my on-location work, along with sketches and photos of the subjects. Examples have been chosen that I believe best illustrate my approach and response to a variety of material.

Figure A-3.
End of the Pier.

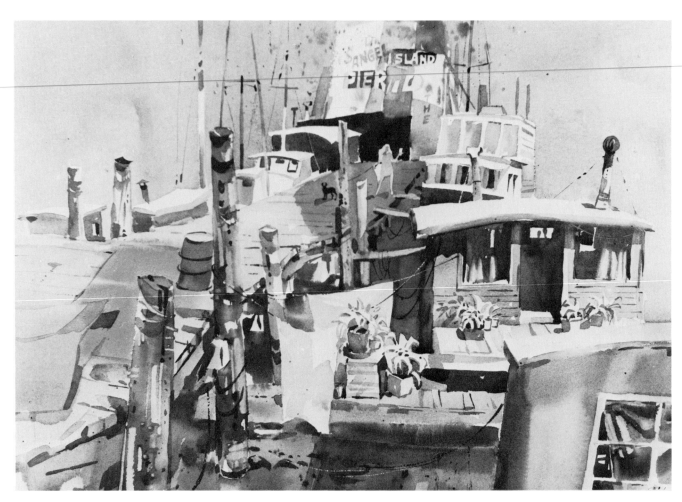

Figure 1-1.
Napa Street Pier, 18x24 inches.

The Style

Techniques, compositions, and mood are endless in variety, as can be seen by comparing the two watercolors, *Napa Street Pier* (Figure 1-1) and *Richardson Bay* (Figure 1-2). In *Napa Street Pier* a sense of excitement is created with a dynamic display of warm colors (yellows, oranges, reds, and violets in the original). The pyramid composition of verticals and overlaps leads you back to the small figure placed against a deep alizarin crimson. In direct contrast is the painting of Richardson Bay, where cool blues and greens, neutralized with burnt sienna and burnt umber, create a placid scene. Horizontals in the composition contribute to the peaceful feeling.

ONE

On-Location Painting Styles

By some magic the pigments we apply to dampened paper merge and spread their charm on our washes. We are fascinated and absorbed when suddenly we discover that watercolor has a life of its own. Colors start running into areas where we didn't want them. Images on our paper melt and dissolve, and watery pigments start chasing each other down the sheet, seeming to say, "I'm going this way." But watercolor can be controlled and guided to go *our* way if we learn what it can and cannot do.

The method we use to control the medium can enable us to produce countless individual painting styles, ranging from the mysterious and spontaneous to the precisely planned and vigorous.

Watercolor's unique visual and artistic potential, which is due primarily to its transparency and spontaneity, has allowed the painter great latitude of technique for experiment and exploration. As a result, watercolor painting has moved forward from traditional approaches to new ways of seeing and doing.

Watercolor, with its chromatic richness and its special possibilities, not only enables on-location painters to capture the ever-changing landscape and its many moods in a direct manner, but also affords us a seemingly endless variety of means of expressing our feelings about the subject.

The equipment and materials we need are relatively modest and easily transported. This, along with the medium's unique qualities, helps to make watercolor painting a popular and gratifying experience no matter what our level of competence.

A Way of Seeing

Painting is seeing, but seeing in a new and special way. As I have said, and will say in a dozen different ways, it is an adventure in *discovery* and *selection*. Sometimes it's easy to paint a subject that has the things it is supposed to have. Quite often, however, we end up with a subject that has a lot of things it is not supposed to have. There is always more out there than we need. We have to develop an *eye* for what is essential and what is superfluous, and for arranging the essentials into a more powerful and significant whole. Developing a painter's eye is necessary, regardless of painting styles and techniques.

While the vitality of a painting can benefit from

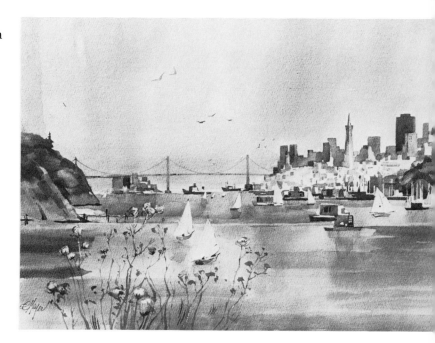

Figure 1-2.
Richardson Bay, 18x24 inches.

an uninhibited attitude and the happy accidents that occur while manipulating watercolor, most successful pictures begin with a concern for controlling space and reorganizing the subject matter. This is a good place to mention, briefly, a few of the concepts and approaches used by painters throughout the world. (All will be discussed in detail later, but if any are unfamiliar and you want information about them immediately, turn to the Index.)

Negative and positive shapes can be arranged in a two-dimensional sense with no regard for three-dimensional depth. Depth is suggested by overlapping flat planes. Movement within the picture plane is also created with a receding progression of shapes without the aid of scientific perspective.

We can develop a feeling of vitality—of tension between shapes or within the object—through spacing, through organization within the picture, or by tilting lines and shapes away from a static position.

Transparency and depth of color is achieved by modulation, laying subtle variations of color side by side. This serves the purpose of making surfaces rich with luminous color. The breaking up of the surface with arbitrary passages of light and dark allows us to animate the picture and avoid a cut-and-dried postcard view.

Watercolor Today

Today's watercolorist utilizes many of these concepts of color, form, and space in a creative interpretation. The on-location painter sees *what's out there* in a new light and captures his or her visions with careful planning and vigorous execution.

Here, in a nutshell, is the procedure we follow. First we make one or more preliminary sketches on a sketch pad to plan the picture. Shapes are overlaid, one behind another, to give the illusion of depth. These shapes are linked together so that lights and darks flow throughout the composition.

After this preliminary planning (to be explained in detail later) we transfer the pencil outlines to the watercolor sheet and dampen the paper. Next we set down the main tones and shapes of the subject with a large flat brush, paying little attention to detail. As the moisture in the paper lessens, we refine values and add smaller patterns of rich color until we achieve a pleasing balance of both color and value. Color is put on with boldness and without overworking, as upon this depends the liveliness of the colors and the transparency of the medium. We obtain light and brilliance by allowing the white of the paper to show through the transparent washes. In some areas the paper is left white as part of the design. The addition of lines, calligraphy, and smaller spots of darks ties it all together.

We have many tricks to give our watercolors technical variety. These include applying paint with various objects such as the wiggly edges of small pieces of cardboard or the flat surfaces of loosely woven fabric, which are first pressed into wet color. Paint can also be applied with sponges and brush spatters. Letting water drip from outstretched fingers onto painted areas before they dry creates unusual effects. Abrading selected areas of the *dry* sheet with sandpaper or a wire brush reveals unique textures when color is painted over these areas. Folding and creasing a soaked watercolor paper will cause darker lines to appear on the tortured areas when paint is applied.

We can achieve additional surface textures by throwing salt into wet passages and by lifting wet paint with acetate sheets or scraps of mat board and printing the wet paint into a variety of other positions.

Using these technical devices in unusual ways can lend excitement and interest to our pictures. But it is only a thorough knowledge of colors and how they interact, as well as the careful application of artistic principles that will enable us to realize the full potential of the medium.

In watercolor, sound concepts and methods for seeing and capturing the light and color of landscapes, figures, and the environment are indispensable. We shall deal with these comprehensively in the chapters that follow.

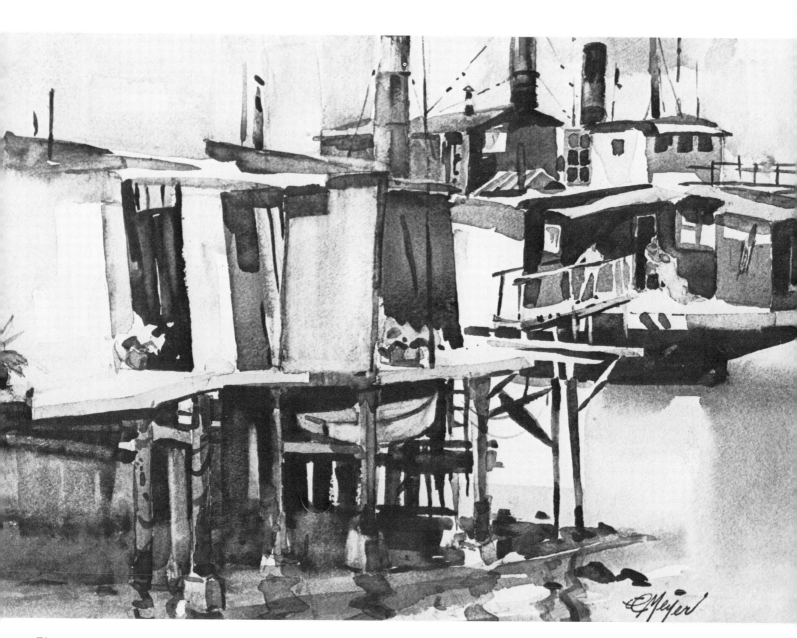

Figure 1-3.
Houseboats, 12x16 inches.

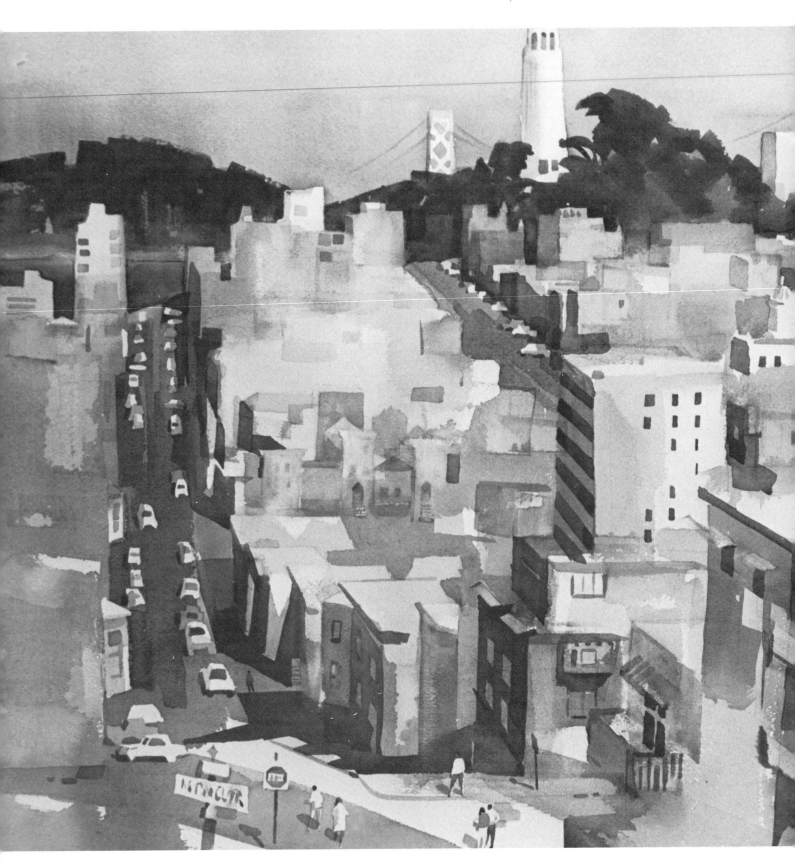

Figure 1-4.
Telegraph Hill, 22x30 inches. Collection of the artist.

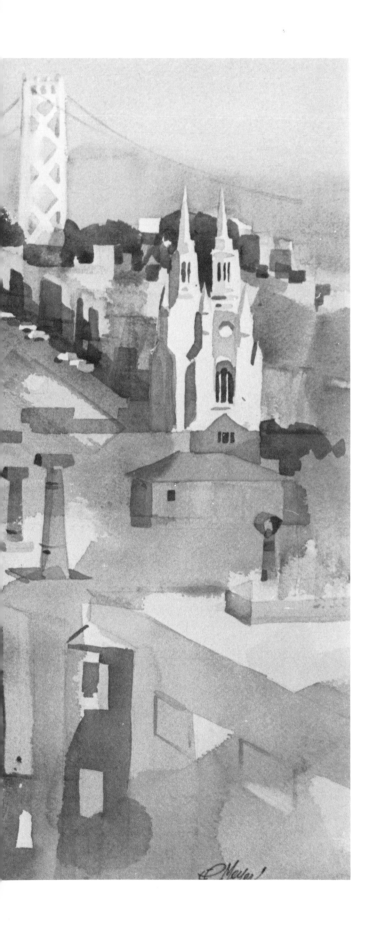

Pattern

I tried to express the busy streets and brilliant shapes of San Francisco in the simplest terms with interlocking patterns of varying size and color. These set up a rhythmic beat of positive shapes, then negative, throughout the painting. Much of the vitality was created by scraping into wet paint with a cut-up credit card.

TWO

Figure 2-1. Edge of Drakes Bay, 18x24 inches.

Figure 2-2.
The author painting on location.

The Power of Design

The visual impact of a painting depends on the way we transpose our subject matter into pictorial form. When we paint a scene we must keep in mind that a sense of reality is necessary so that the painting can communicate with the viewer. Yet the way a thing is recreated on paper can make it look even more real, more powerful, and more vigorous than it really is.

Shown here are two versions of the same subject. Figure 2-1 was painted from a hill overlooking Drakes Bay, where an interesting grouping of buildings at the edge of the bay is presented in a serene display, much as the scene actually appears. Figure 2-3 was painted from the shoreline in back of the buildings. Here there was an exciting abundance of material scattered about, from which more distinct forms and order needed to be created. While nature often confuses the on-location painter with an excess of material from which picture-making elements need to be selected, at other times she presents us with a more perfect relationship of shapes and values, but without a mood or sensitivity. In either case it is necessary to find a satisfying solution in the act of painting.

The painter needs to create with imagination, to interpret the subject freely. To provide pleasurable visual sensations, the image can be fractured somewhat and redistributed by rearranging or exaggerating the patterns and shapes. Rhythmic patterns of light and dark need to be displayed with careful modulation of contour and edges to maintain a "lost and found" quality (see "Painting Terminology" page 157. Flowing calligraphic lines, along with textured areas, will enhance the effect.

Movement

In the painting reproduced here, I used the white path of oyster shells in the foreground to lead the viewer in and to the point of interest. Light areas within the darks create vitality and focus attention. Drips and runs in the foreground are echoed in tree and sky areas. The quickly painted patterns and shapes, while appearing awkward at times, benefit from this awkwardness in setting up a conflict of clashing values that contributes to the visual excitement. Scrapings into wet paints, along with paint spatters, enliven the foreground areas.

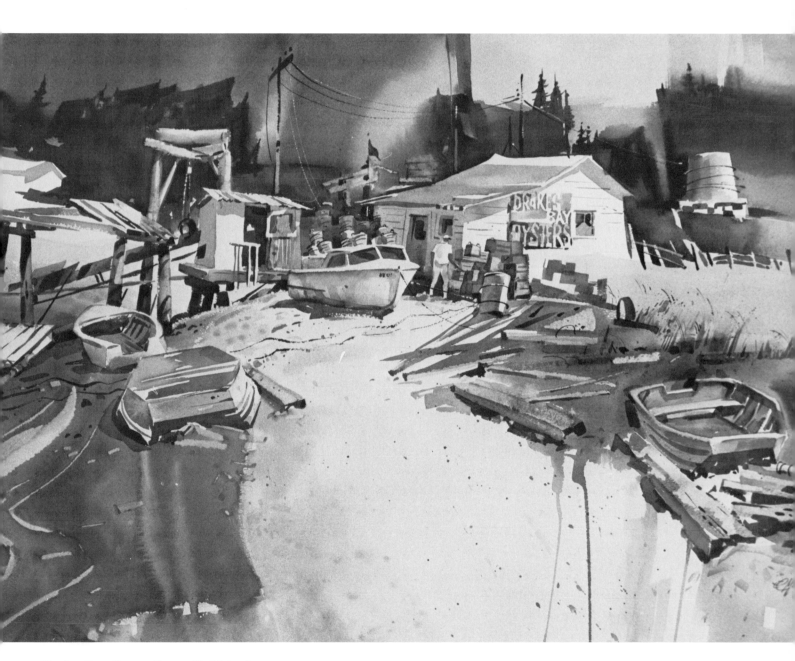

Drakes Bay Oyster Farm, 22x30 inches. Collection of the artist.

Figure 2-3.

Distribution of Light

Light is the artist's most important tool. Paper whites can be used to make a painting glow with light. A rhythmic distribution of light and dark patterns captures and holds our attention. Other design elements—texture, direction of line, color, and value—are necessary to unify the composition, yet it is the intervals of paper whites throughout the painting that give it a unique sparkle.

Figure 2-4.
Barn Interior, 14x21 inches.
Collection Mr. & Mrs. R.T. Hinze.

Distribution of Values

This shoreline scene contains a patchwork of middle tones that link the light and dark shapes of the subject. The light and dark relationships that exist in nature are exaggerated in this value sketch to illustrate this phenomenon. The monotonous scattering of lights and darks that often occurs in watercolor painting can be corrected by glazing over some of the light areas and by lifting color from some of the darks.

Figure 2-5.
Inverness Shore value sketch.

Positive and Negative Shapes

The intervals of light and dark in a composition can also be seen as positive and negative shapes. Positive shapes are generally considered to be the shapes of the objects themselves, while negative shapes are considered to be the spaces around and between the positive shapes. In a painting with a dark background, the positive shapes are often white or light in value. At other times, as in Figure 2-6, the positive shapes are dark. This alternating dark-light spacing sets up a rhythm that I try to get into my watercolors.

Figure 2-6.
The landscape near my studio.

Nature's Patterns

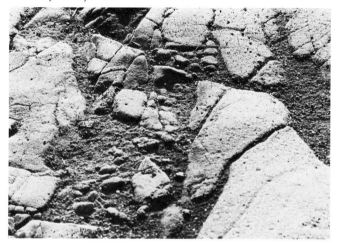

Figure 2-7.
Photo of rock forms.

Figure 2-8.
Photo of nature's patterns.

The continuous pounding of waves has etched a variety of lines and patterns on coastal rock forms. Shown in these photographs are a few examples of nature's flowing lines, unequal space division, and intricate surface embellishments.

The artist who is at the stage of being too precise with space organization, and who has a tendency to brush lines all of one width or of equal spacing and direction, will benefit from studying the variety of lines, patterns, and forms provided by nature. This should not be limited to the few examples shown here but could include tree and plant forms, cloud formations, the figure, and countless other subjects.

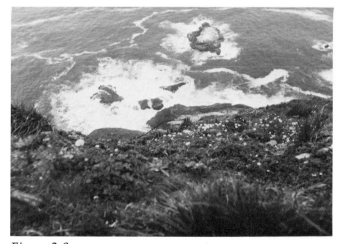

Figure 2-9.
Photo of surf at Point Reyes.

Contrast and Textures

As this photograph shows us, the visual interest of any object is enhanced by the contrast between smooth areas and textured ones. In watercolor painting we can suggest texture in a number of ways, as we saw in Chapter One, under the heading "Watercolor Today." While such texture-making methods can create exciting surface interest, you can give a watercolor much vitality by painting part of it wet-into-wet and then balancing this with hard-edged shapes. Some elements of a landscape, such as clouds, fog, mist, water, and distant hills, lend themselves quite well to a wet treatment, while other parts of the scene, such as rocks, pebbles, cliffs, or nearby objects, are better treated with controlled washes and hard edges.

Figure 2-10.
Felt-tip pen sketch of Yuma dunes.

Rhythm

Long shadows cast upon a hilly terrain or upon mountain forms create a dark-light alternating rhythm that is pleasing to the eye. The best time to observe these undulating shadows is early in the day or late in the afternoon. (I enjoy painting in the winter when the sun is low and creates long shadows, even at high noon.)

Nature presents a number of subjects that are dominated by a consistent, repeating rhythm, such as ocean waves, receding tide lines on the beach, a flight of gulls, sails in motion, and many others.

Surface Embellishments

No matter how varied or imaginative the space division we use in depicting subject matter, we can make the painting much more interesting by embellishing the surface with calligraphic line work.

Calligraphy is a basic art form that can be used to describe, embellish, and enrich. As it skips around through shapes, it echoes them and enhances a feeling of movement within the composition, as can be seen in the painting *Redwoods* (Figure 2-11). Here calligraphy not only depicts numerous tree branches but also serves to tie together the large shapes with diagonal, crisscrossing strokes of the brush.

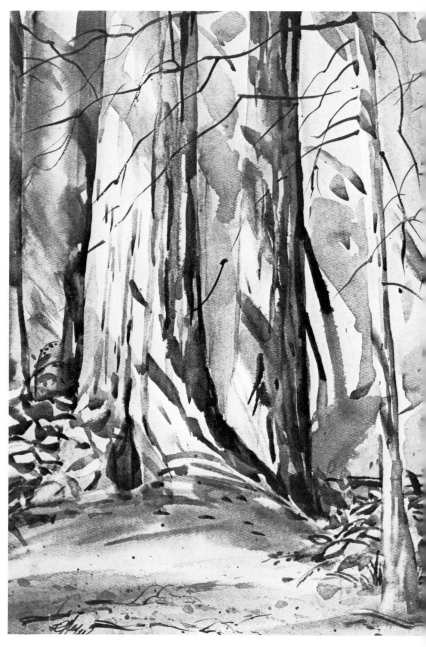

Figure 2-11.
Redwoods.

23

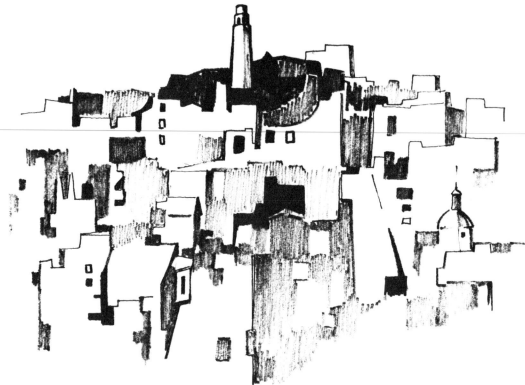

Figure 2-12.
Telegraph Hill.

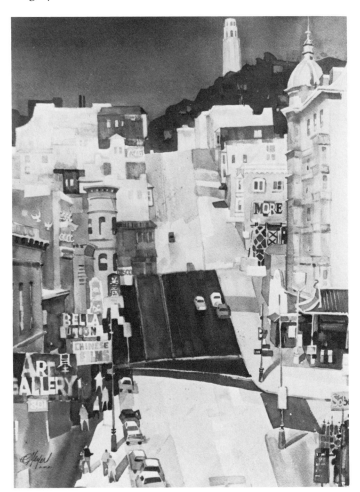

Overlapping Planes

By using overlapping planes, one behind another, we can suggest an illusion of movement, of objects extending back into the distance. In the sketch shown here (Figure 2-12) there is no convergence to a vanishing point nor is there a decrease in the sizes of the planes as they recede into depth.

Reality

To avoid losing reality, I used a combination of both overlaps and a convergence to a vanishing point in the painting *Kearny Street Hill* (Figure 2-13). The use of perspective is noticeable in the foreground, where lines of curbs, sidewalks, windows, and rooftops converge to a point near the center of the picture. From this point on, the sense of depth depends upon overlapping planes, which help to convey the feeling of a steep hill without the funnel effect that often occurs in perspective projections. The feeling of light is enhanced by the arbitrary placement of darks next to the lights.

Figure 2-13.
Kearny Street Hill, 30x22 inches.

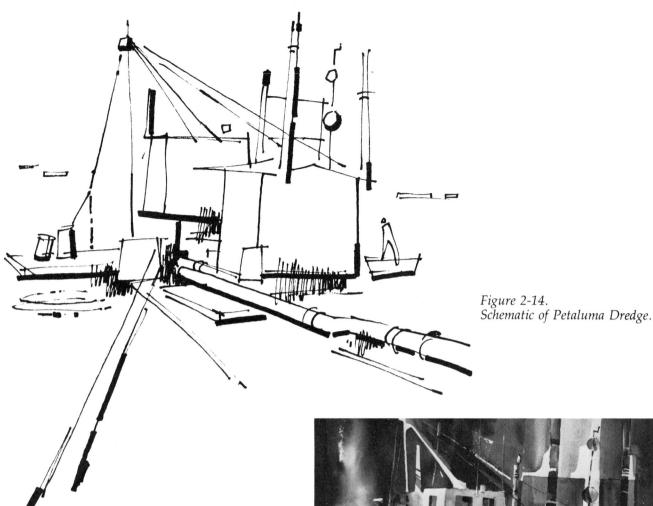

Figure 2-14.
Schematic of Petaluma Dredge.

The Distorted Image

As this preliminary sketch suggests, exciting compositions can be created through distortion and exaggeration. Deliberately introducing thrusts and counterthrusts that lean away from static verticals or horizontals can give a composition a lively, dynamic quality. Often the artist, striving for a camera-like copy, misses the opportunity to put some punch and a personal statement into the design.

Creativity

This realistic watercolor (Figure 2-15), based on the sketch above, shows a creative interpretation with leaning, twisted images. When you distort like this you must be careful. Don't slant all shapes in the same direction or the design will have a disturbing illusion of falling over. A selective placement of shapes and values helps to stabilize the subject.

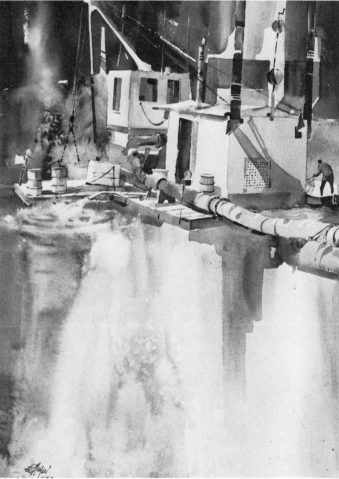

Figure 2-15.
Petaluma Dredge, 30x22 inches.

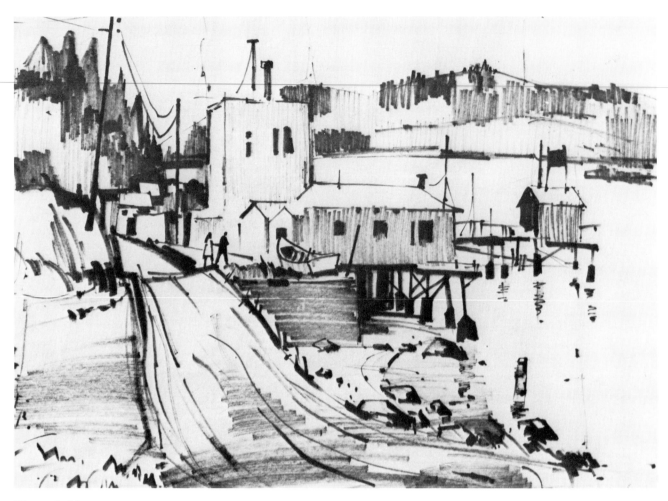

Figure 2-16.
Felt-tip pen sketch.

Imaginative Interpretation

These two sketches and the photographs of the scenes on which they are based emphasize how you can redesign ordinary subject matter into compositions that have vitality and interest. Rather than copy the scene in all literalness, I omitted the superfluous and arranged the essentials into a more effective, meaningful display.

These sketches were developed from prior notations and thumbnails made on location, where I searched out those things that would allow an imaginative interpretation of the scene. To make it easier to say something vital about a subject, some artists think out how they will arrange their shapes and values, then turn their back to the scene and paint from memory. Memory exaggerates the essentials and makes it easier to put some of your personal feeling and imagination into your work, thus saying things the camera can't.

Figure 2-17.
Photo of subject at left.

Figure 2-18.
Photo of subject below.

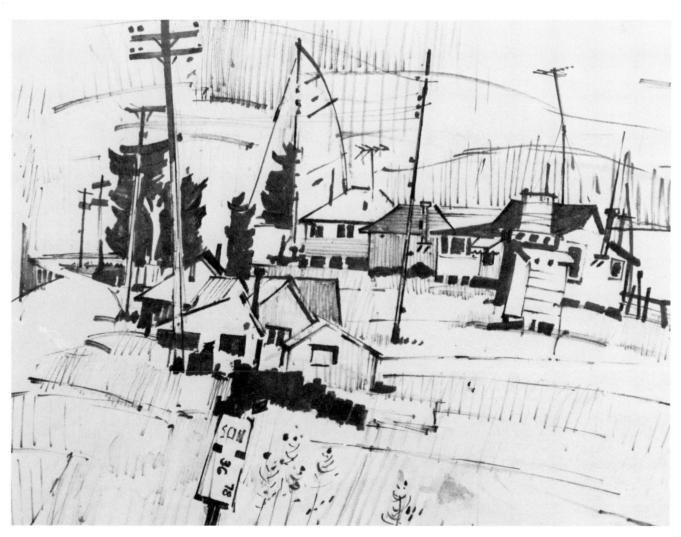

Figure 2-19.
Felt-tip pen sketch.

THREE

On-Location Materials and Equipment

Easels

Painting on location, unlike studio painting, requires mobility. The kind and the amount of equipment you need depends on personal preferences, including whether you prefer to stand or sit while painting.

Standing allows greater freedom of arm movement, which is essential for vigorous results. Standing while painting also makes it easy to step back several paces from time to time to judge your progress.

There are a number of easels available at art supply stores that are designed for the watercolorist. While most of the light tripod easels have a decided advantage when it comes to transporting them any distance, they won't stand up when the breezes start gusting, as they do on occasion. I have found the French box easel shown here to be most reliable for on-location work.

I have used many kinds of easels, boxes, camp-stools, and folding tables at one time or another. Sometimes when I plan a long painting hike I don't carry an easel but merely prop my board up on a rock or other handy object. On one such occasion the view I wanted was in a boatyard and could only be seen by standing. Fortunately, I was able to borrow two nearby empty oil drums, one for my board and the other for my palette, brushes, and water can. This arrangement was completely satisfactory, but one can't always be this lucky. Good equipment isn't always necessary, but it helps.

Because I paint most of my watercolors while standing, I prefer the French box easel. It is very sturdy and the adjustable rack holds the board securely against the inevitable gusts of wind that occur along the coast. Many watercolorists use this easel, although it was designed primarily for the oil painter. There is a similar easel on the market that

Figure 3-1.
Photo of receding tide, Sonoma coast.

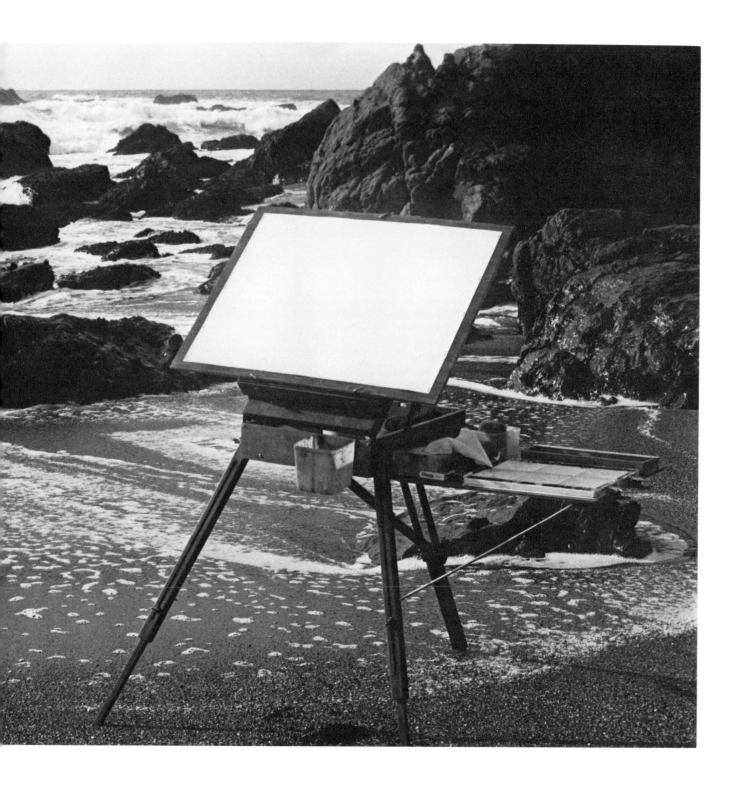

is designed especially for the watercolor painter. It has a detachable shelf to hold palette and brushes.

If you use the pull-out drawer of the French easel to support your palette you have no doubt discovered that you can't get comfortably close to your work. I solved this by eliminating the drawer and devising a detachable palette support, as shown here (Figure 3-2).

By eliminating the pull-out drawer, I reduced the weight of the easel considerably. This arrangement also makes room for a number of bulky items such as a box of tissues, lunch, camera, plastic water containers, etc. The water containers have a bent strip of thin metal fastened to the outside with two small machine bolts. The metal strip is shaped so it will hook over a thin piece of plywood that has been fastened to the front of the easel with several wood screws. The water containers can also be hooked over the front or side of the pull-out drawer if you prefer to keep the drawer intact.

The palette support board is a ¼-inch-thick piece of plywood, 16x24 inches, that is first fastened to the lower right edge of the easel with hinges that have removable pins. The hinge pins are then temporarily removed so that the halves of the hinges on the plywood board can be opened with a screwdriver, just far enough so the board can be hooked onto the hinges on the easel when the board is raised to vertical position. The hinge pins have, of course, been replaced and no longer need to be removable. Locating the hinges 4½ inches in from the end of the palette board allows this end to lap under the easel, to hold the board securely in a horizontal position when it is lowered (Figure 3-3).

If additional support is desired, a ¼-inch-diameter steel rod can be used, as shown. One end is bent to fit into a wood block that has been glued to the underside of the palette board. The rod is then cut to the correct length, so that the other end will slide into a hole bored halfway through the right leg of the easel.

Figure 3-2.
French easel with palette support.

Figure 3-3.
Pull-out drawer replaced with plywood front.

Painting While Seated

Most tripod easels do not grip the board firmly enough. Any slight pressure at the ends causes the board or drawing pad to flop around, which is not very conducive to control of the watercolor medium. The watercolor easel shown in Figure 3-4 was altered so it would securely hold a ⅜-inch-thick plywood board that can be tilted to any position. A grooved wood block is fastened to the back of the board with wood screws. The metal clamps of the easel fit into these grooves and hold the board securely.

The setup shown in Figure 3-5 is facing the sun. The board is tipped upward so there is no direct glaring sun on the painting surface. If you want your board to be in a nearly flat position for better control of your washes, it's a good idea to find a shady spot to work in. Trees sometimes provide good shade, but if they allow a flickering play of sunlight on your paper, they are worse than no shade at all and you are better off to work out in the open. Note the strip of wood glued to the front bottom edge of the plywood board. This supports

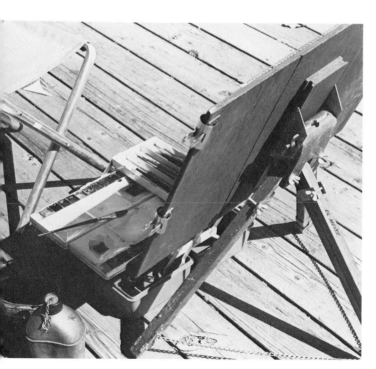

Figure 3-4.
Back view of easel and board.

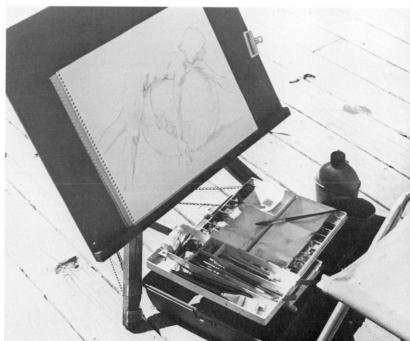

Figure 3-5.
Facing the sun with paper in shade.

31

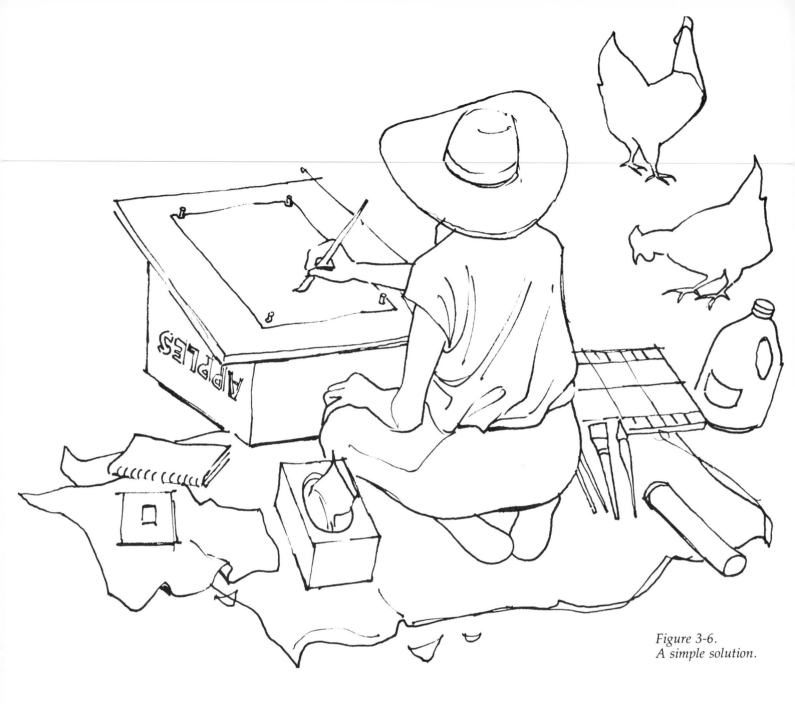

Figure 3-6.
A simple solution.

papers or drawing pads, or separate boards on which watercolor papers have been stretched.

Some artists paint with the board supported on a box that holds all supplies. Figure 3-6 shows a corrugated paper carton with the top cut at a slant of about 15 degrees to support the board. Other painters simply prop the board up on a rock or other handy object. (While I was sketching this painter and her painting setup, several chickens wandered over and started pecking at her palette, going only for the yellow colors.)

Dealing with the Elements

Outdoors, the sun and wind will quickly dry out the paints on your palette. Colors need to be kept moist so that you can get a brushful of juicy color when you need it. An ear syringe is useful for squirting water onto the colors to keep them moist. Another useful item is an atomizer spray bottle, such as a Windex bottle, filled with clean water. It can also be used to keep colors moist, but is most useful for adding moisture to the watercolor paper for certain effects, or to keep the paper from drying too fast.

Painting in Your Car

The glistening reflective surfaces and misty appearances of landscapes on a rainy day are a challenge and an invitation for juicy, wet-into-wet treatments. When rain or other weather conditions make it impossible to set up your easel out in the open, you can often find a good sheltered spot in the doorway of a barn or under a porch or awning. Some artists paint in their cars, and various schemes have been devised to make this easier. A roomy van is, of course, ideal.

When you are forced to paint in your car, you will be well prepared if you have a combination paint box and easel like the one shown in Figure 3-7. It simply rests on your lap and is compact and easy to build with pine molding for the sides, ¼-inch plywood for the top, and thin mahogany door paneling for the bottom. Outside measurements are 16x22x2 inches deep. It is designed for two Eldajon palettes (see next page). If you use the Pike or other palette, these dimensions need to be increased so that your palette will fit inside, where it will keep paint from splashing around. The lid measures 12x16 inches and is hinged to the top of the box, as shown. When open, the lid can be adjusted to any slant with a support bracket. Quarter sheets of watercolor paper (11x15 inches) can be clipped to the open lid. Larger papers can be clipped or stapled to separate plywood boards, which are then supported by the open lid. If desired, two U-shaped pieces of metal can be fastened to the lower inside edge of the lid to keep the larger boards from sliding. Water can be in a container that hooks to the outside edge of the box, where it is convenient and unlikely to get spilled.

Lightweight and easy to carry, the box holds brushes, palette, paints and other supplies. Although it is designed to be held on your lap, you can also use it outside your car by placing it on a campstool or card table.

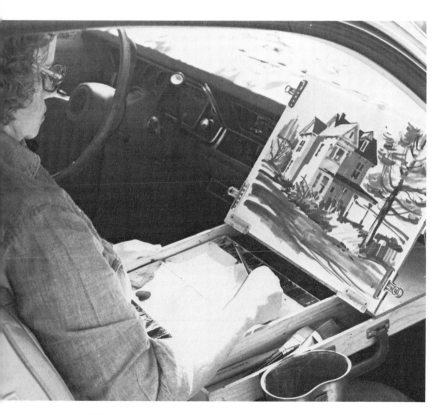

Figure 3-7.
A compact homemade paint box.

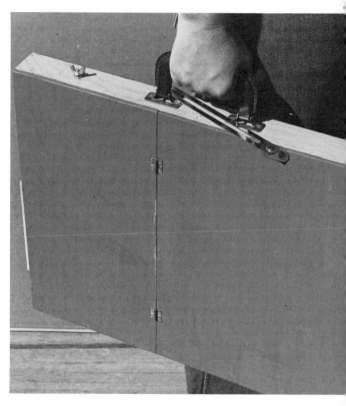

Figure 3-8.
Easy to carry on sketch trips.

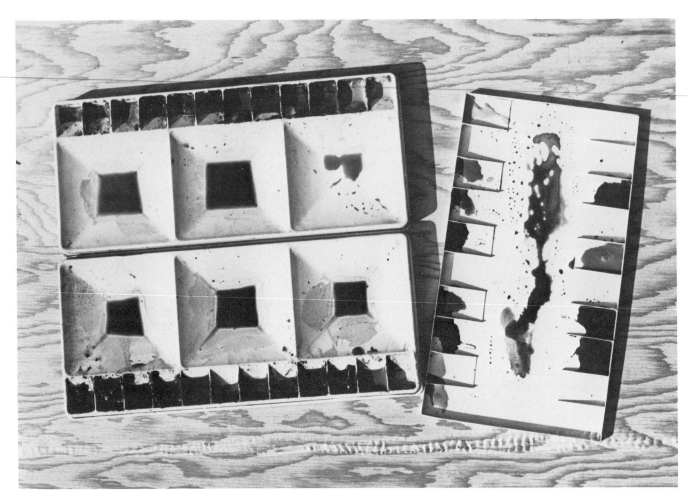

Figure 3-9.
Eldajon palettes at left, O'Hara palette at right.

Palettes

There is a large selection of palettes on the market for the watercolorist. Each has its advantages and disadvantages. One of the problems with some palettes is that colors run into each other during transport unless the palette is carried flat, which is often difficult or impossible. I prefer to use two Eldajon palettes (Figure 3-9), which can be stacked flat, one on top of the other, in the bottom of my supply box. Colors can be kept moist at all times, ready to go. I also like the separate mixing wells. During use the palettes are clipped to the palette support board of my easel, as previously shown, to prevent them from being blown away by an occa-sional gust of wind.

A palette that I find very convenient when I go sketching is the O'Hara palette (shown at right in Figure 3-9). This palette fits into the O'Hara sketch box, which measures only 6x11x1¼ inches, yet also has room for paint tubes, brushes, pencils, and pens.

For studio work, I often use the Pike palette, which has a large flat mixing area and a lid that can also be used to mix colors. A damp kitchen sponge placed on the palette before closing will help to keep colors moist between painting sessions.

Paints

My choices of paints and their arrangement on the palette are shown in Chapter Seven, "Seeing Color." From the large number of tube colors available I use the finest Artists' Colors in both Winsor & Newton and Grumbacher paints. Although my palette contains colors that I use all the time, I also like to experiment with new colors and replace the less-used colors with these. Some, like brown madder alizarin, neutral tint, aureolin yellow and Indian red are useful because of their special properties. For most work I rely on a few warm colors and a few cool ones. The warm colors that I most often use are yellow ochre, burnt sienna, new gamboge and alizarin crimson. Most frequently used cool colors are Winsor blue, permanent blue and cerulean blue.

To keep caps from sticking, the threads on the tubes need to be kept clean. An easy way to do this, after squeezing out color, is to dunk the end of the tube in water and then wipe it with a paper towel or tissue. Paint that is left on the threads gets gummy or hardens, making removal of the cap difficult. If the cap won't turn, try holding a lighted match under it for a few moments. In extreme cases a pair of pliers will help loosen the cap.

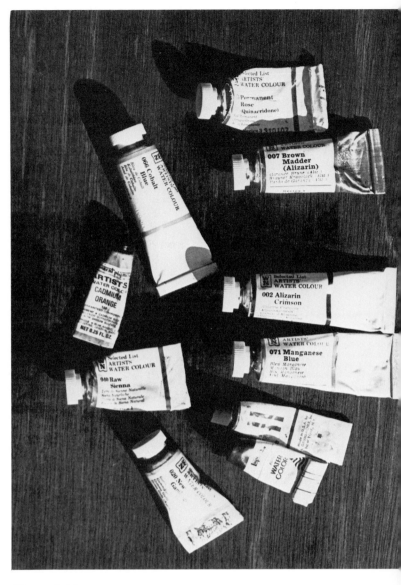

Figure 3-10.
The best paints are the professional artists' watercolors that come in large No. 5 tubes (shown here) and small No. 2 tubes (not shown). Student-grade paints, made by many leading paint manufacturers, come in long thin No. 3 tubes and are used mainly for rough sketches.

Paper

Choosing the right paper is most important because paper not only determines the behavior of watercolor paints but also has an influence on painting techniques. Ideal papers are made of 100 percent rag, and are available in 140-pound and 300-pound weights. Ninety-pound papers are also available but are too thin for most work. Surfaces are hot-press (smooth), cold-press, and rough. Most of my work is done on 140-pound Arches cold-press and rough papers. I also use Fabriano, Capri, and other handmade papers, along with Strathmore and Borden & Riley papers and sketch pads.

The 140-pound paper is prestretched by saturating the sheet with clean water for about five minutes and then stapling it to a ⅜-inch-thick plywood board. The board is about an inch larger than the paper all around. I try to keep two or three prestretched papers on hand, ready to paint on.

To soak the sheet, place it on a clean, flat surface and saturate it by carefully brushing first one side and then the other with clean lukewarm water, using a 2-inch-wide brush as in Figure 3-11. The sheet is then held in a vertical position for several minutes by grasping one end (Figure 3-12). This allows the water to saturate the paper evenly and thoroughly without the buckling that occurs when the sheet is allowed to soak in a flat position. When the flow of water starts to drip off the bottom edge, the sheet is turned end for end to allow the water to

flow in the opposite direction. More water is brushed on if the sheet is drying too quickly. Brushing the paper with clean water also removes some of the protective sizing that covers the sheet. Removing the sizing makes the paper more receptive to watercolor paints.

When the sheet is thoroughly saturated, it is placed on the plywood board and stapled on all sides with a heavy-duty stapler. Staples are placed about ⅜-inch in from the edges and at 2-inch intervals (Figure 3-13). Any buckling that occurs after the sheet has been stapled is normal. Just leave it alone and it will dry tight as a drum. Paper that has been prestretched will not buckle during the painting process.

Instead of stapling, I sometimes use 2-inch-wide butcher tape to fasten the soaked sheet to the board. Excess moisture needs to be blotted from the edges with a paper towel or the tape won't stick. Even so, I have found that the tape doesn't always hold and will pop loose. To make certain that it will stick, you can run a thin bead of white glue around the front edges of the paper before applying the tape. The tape should be moistened carefully on the gummed side with not too much water. (A squeezed-out sponge works best.) After the tape has been applied it must be pressed down firmly with a soft cloth.

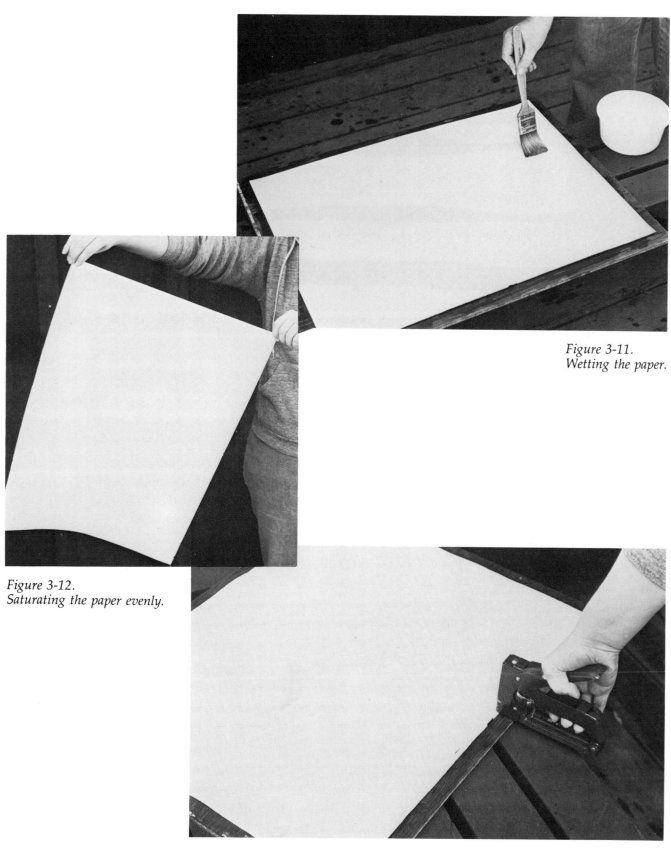

Figure 3-11.
Wetting the paper.

Figure 3-12.
Saturating the paper evenly.

Figure 3-13.
Stapling the paper to the board.

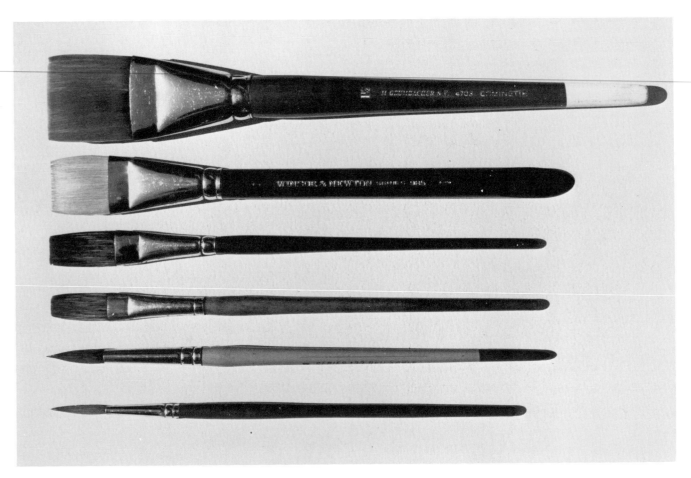

Figure 3-14.
Brushes that I use most frequently are, from top to bottom, a 1½-inch flat synthetic fiber; a 1-inch flat synthetic fiber; a ⅝-inch flat red sable; a ½-inch flat red sable; a No. 8 round red sable; and a No. 6 sable script liner.

Brushes

Brushes are the basic tools that enable us to create an infinite variety of washes, patterns, and textures. Different brushes give different effects. Some brushes are designed for painting thin, twisting, flowing lines while others are better suited for painting broad, angular, choppy strokes. An artist's style is often determined by the kinds of brushes used or by the tempo of the brushstrokes.

When buying brushes you should test them to see if they will do what you want them to. Most art stores keep a jar of clean water handy for this purpose. Brush hairs should be resilient and bounce back quickly to their original shape. Round brushes should maintain their point, and flat brushes should have a clean edge. Sable brushes are of course the best, and will last a lifetime if well taken care of. But they are also the most expensive. Today there are many synthetic fiber brushes on the market that do a fine job and are most economical. I have found they are good performers and hold their shape well. A selection of sables in the smaller sizes, augmented with larger brushes made of synthetic fibers, seems to satisfy most needs.

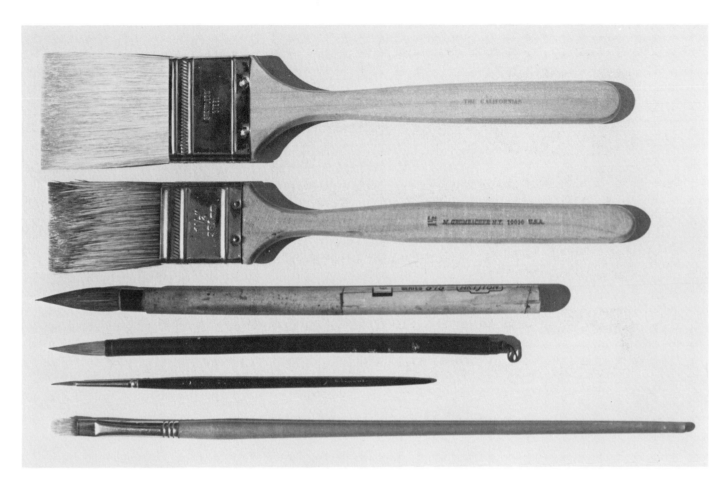

Figure 3-15.
Brushes that I use less frequently include, from top to bottom, a 2-inch flat white bristle; a 1½-inch flat white bristle; a No. 6 oriental round; a No. 4 oriental round; a No. 3 round red sable; and a No. 4 flat bristle brush.

Figure 3-16.
Some tools and items that I find useful include small matboard scraps for imprinting lines; painting knife; pocket knife; fabric pieces for imprinting textures; sponges; coarse sandpaper for abrading areas of the paper; razor blade; and cut-up credit cards for scraping into wet paint.

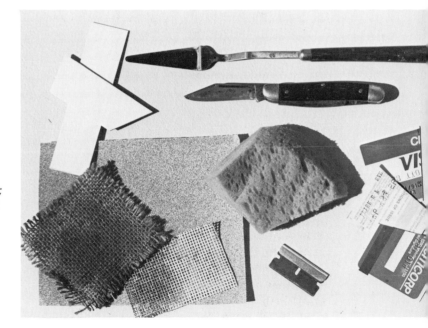

Sketchbooks and Sketching Tools

Sketchbooks and sketching papers come in all sizes and varieties of surfaces, ranging from the smooth and hard to the rough, absorbent kind. Each paper allows you to achieve a different effect. I enjoy working on a variety of papers and have discovered new ways of creating surface textures in doing so. Many of my sketches are merely quick little thumbnails, for which almost any inexpensive paper, including typing paper, is suitable. (I always keep a supply of typing paper on hand.) For detailed sketches and for sketches I want to keep, however, I prefer to use a good-quality paper, one that responds to the sketching tools that I am using. Among many good-quality papers are the Strathmore series. Figure 3-17 shows some of the papers and tools that I frequently use. Sketching tools include charcoal, soft pencils, felt-tip pens, and felt-tip markers.

Fiber-tip pens are versatile for fast sketching. Felt markers in several shades of gray are very useful for planning value structures. Uniform, broad areas can be covered quite rapidly. Markers bleed through some papers, so when you draw on a pad it is necessary to place a hard surface under the sketch to protect sheets underneath.

Sketching On Location

The outdoor painter will find great rewards in acquiring the sketchbook habit. There is no better way for you to get to know your subject or to help you plan a simple value structure for your painting. Sketches allow you to try different approaches before starting the watercolor painting. Of particular importance is the need to determine where to leave areas of white paper, as this is the key to getting sparkle into your watercolors; these untouched areas of paper also function as an important part of the design.

When looking for material to sketch, I try to avoid complicated subjects and search instead for things with strong, simple patterns that are easier to translate into paint terms. Sometimes when I'm sketching I let my hand wander across the paper and am always amazed at how quickly the mind selects and rejects. This is something the camera is unable to do. It gives you all, good and bad.

When I sketched the view of sand dunes at Salmon Creek shown here (Figure 3-18) I was looking toward the Pacific into the glaring sun. The bright light created a strong contrast of white dunes against a colorful foreground of autumn ice plants. The ice plants were an intense alizarin crimson,

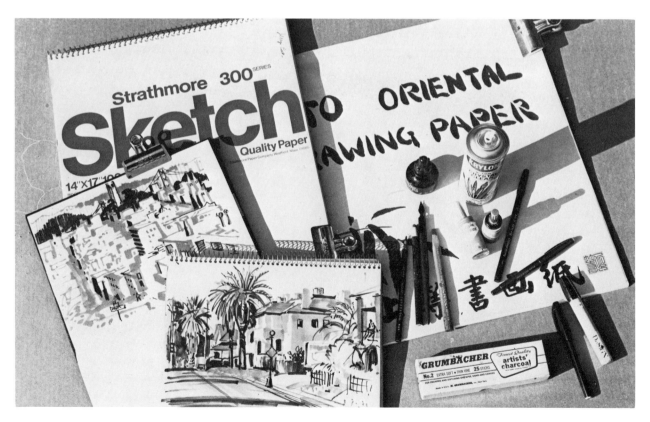

Figure 3-17.
I use both spiral-bound and hard-cover sketchbooks in a variety of sizes.

40

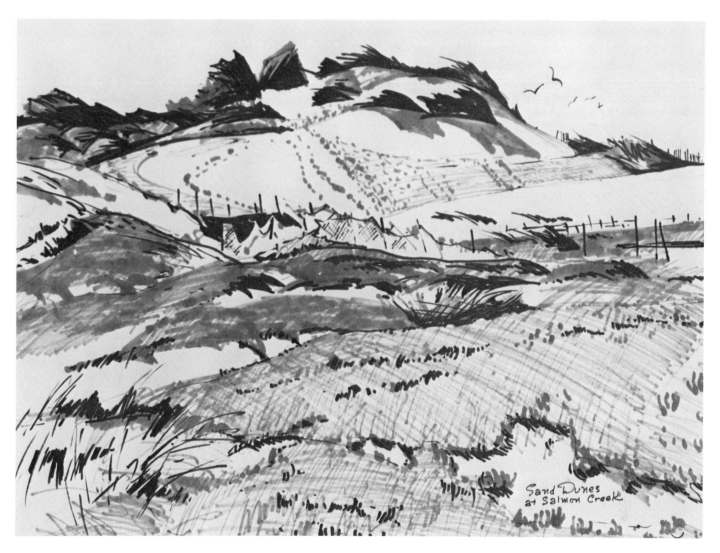

Figure 3-18.
Sand dunes sketched with gray and black felt-tip markers.

muted here and there with soft gray-greens and si-
ennas.

The afternoon light helped here as it allowed me
to see the subject in large, simplified value con-
trasts with little detail. I wanted to capture the bril-
liance of the white dunes and knew that in order to
do this I needed to surround them with values and
color that would make them command attention.
As I was working on the sketch, nature lent a help-
ing hand (it often does when I'm out painting) and

cast lengthening shadows of blue-violet across the
top of the dunes.

This composition benefits from the use of diago-
nals that lead the viewer's eye back and forth, from
the foreground up to the top of the painting. These
diagonals give movement to the composition and
break the picture surface into shapes of various
sizes. The footprints function as part of the design
by embellishing the surface, and by helping to lead
the eye in and up through the white sand.

The tree stump shown here was sketched with felt-tip markers in three values, a light gray, middle gray, and black. Seeing in your subject large middle-value silhouettes will allow you to quickly approximate and arrange your major shapes. Dark values are carefully placed to further define form and pattern.

Figure 3-19.

This value sketch was done in a life class. It combines both charcoal and wash to search out patterns of light and dark. Quick sketches train you to refuse to see detail, to view your subject only as large, simple values coming together.

Figure 3-20.

This value plan was made with lampblack and a 1-inch, flat synthetic brush. Direct sunlight washed out all values represented here by white paper. Shadows created pattern, and reflected light made some of the detail within the shadows visible. Lack of light created the dark recesses of windows and doorways.

Figure 3-21.

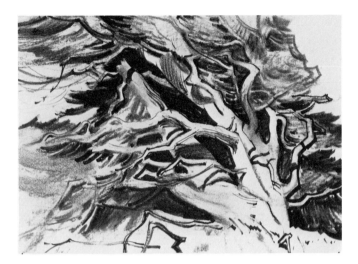

Pine tree rhythms are expressed here with a forceful display of windblown limbs and branches. The strong value contrasts were searched out with charcoal, leaving areas of white, and then fortified with darks made with a felt-tip pen.

Figure 3-22.

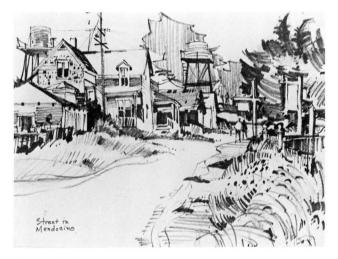

This Mendocino street scene was sketched with a chisel-tip pen. A rhythmic unity in feeling was created by using happy similarities in the shapes of buildings and in the flowing lines of roadway, grasses, and pine tree.

Figure 3-23.

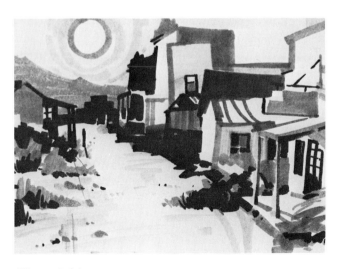

I sketched this movie set of an Old West town with gray felt-tip markers. The attempt was not to depict the scene literally but to arrange the elements interestingly, back and forth, up and down, vertically and horizontally as well as diagonally, to develop a strong design.

Figure 3-24.

Figure 4-1.
Ocean Spray, 17x23 inches.

FOUR

Watercolor Techniques

The amazing possibilities of watercolor painting not only make the medium exciting but provide you with a fascinating variety of means for creating different effects. Some of the techniques are useful mainly as methods of creating surface interests, while others, such as brush handling, are an inherent part of watercolor painting. Those that I have found most useful on location are:

Forcing drips and runs
Salt textures and paint spatter
Stampings, scrapings and lift-offs
Luminous washes and paper whites
Dry brush
Wet-into-wet
Blending washes
Controlled washes
Brush handling

In this watercolor, a variety of effects was achieved by painting into both wet and dry surfaces. For example, I tilted the paper in different directions as I applied more paint, causing the paint to break loose and cascade down the sheet. Values were lightened in some areas by lifting paint with a squeezed-out brush. Color, in varying degrees of wetness, was spattered onto the sheet, and salt was thrown into wet paint.

Some of the surprising results didn't become apparent until the paper had dried. As is the case with all techniques, the best way to learn how to create effects like these is to experiment and then to examine your work carefully afterward.

Stampings, Scrapings, and Lift-offs

In the painting *At Low Tide* (Figure 4-2) I first splashed water at random onto the surface of a sheet of hot-press paper. Light and dark values of Winsor blue and burnt umber were then brushed onto the paper. When the paint hit the wet areas it quickly diffused, but remained hard-edged where the paper had not been moistened. The paper was kept in a flat position to help control the flow of both water and paint.

In the foreground area, I spattered paint onto the paper by tapping a loaded brush against a pencil held about six inches above the paper. Additional texture was created by sprinkling salt into wet paint. Color was lifted in a few areas with a squeezed-out brush. I used a cut-up credit card to scrape a variety of lines and shapes into the distant shore just as washes started to set up. When the paper had dried, boards and pilings of the rickety wharf were stamped in with the edges of mat board scraps to which color had been applied. A stencil was cut from an index card to serve as a template for wetting and wiping hard-edged shapes out of dried washes.

Luminous Washes and Paper Whites

The quality of transparent watercolor depends on an unlabored, spontaneous execution. To keep the tones transparent it is essential to put the washes down and then leave them alone once they start to dry. Overworking washes by changing your mind during the painting process causes muddiness and loss of clarity.

To achieve luminosity, allow the clean white of the paper to glow through the transparent washes. Clean paper whites contribute much to the effects of light and should be incorporated into the design elements of the composition. When you have decided where you want to save paper whites, premoisten the sheet in all but these areas. Color can then be freely brushed or dropped into the moistened areas. Basic washes can also be brushed around your intended whites, or the paper can be moistened with light yellow ochre wash to make it easy to see the areas you are saving for your whites. The yellow ochre wash also provides a good base for succeeding washes, especially in skies, since it is a neutral yellow that works well with most colors.

Note the whites in *Hop Kilns* (Figure 4-3), which were saved by brushing color around them. You can save small areas of white by covering them with masking liquid, which is removed after paints have thoroughly dried. See "Painting Terminology," page 157. I prefer to brush color around all of my whites, as it produces a more spontaneous effect.

Dry Brush

Textures of old boards like the ones in *Empire Gold Mine* (Figure 4-4) are best achieved by holding the brush nearly flat and dragging a premixed pigment across the surface of the paper. Use little water—the paint needs to be more concentrated than when laying a juicy wash. A flat brush works best on large areas; a pointed brush is better for making thinner lines. In either case, however, the brush needs to be held nearly parallel to the surface of the paper. A quick movement of the brush is necessary to keep the color from sinking into the paper. Dry brushing a complementary color over a previous wash that has been allowed to dry will create a lustrous texture.

Dry brushing should not be overdone and looks best when used in conjunction with wet passages.

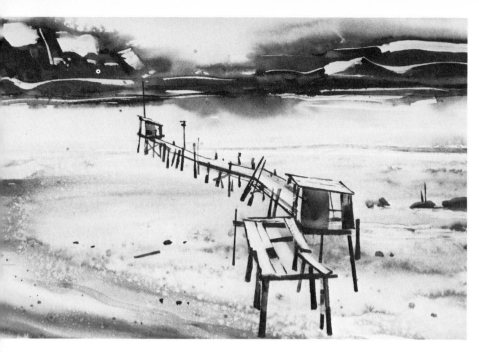

Figure 4-2.
At Low Tide, 14x21 inches.

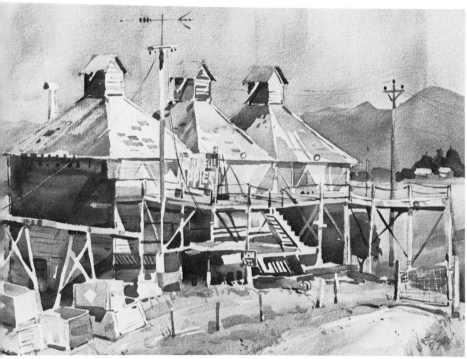

Figure 4-3.
Hop Kilns, 18x24 inches.

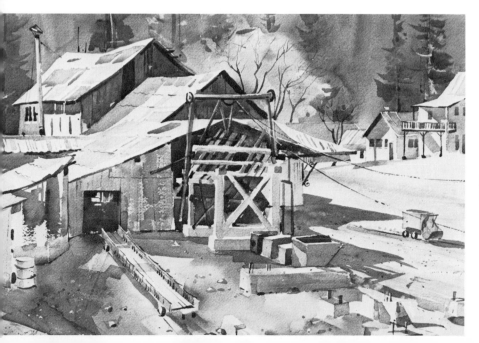

Figure 4-4.
Empire Gold Mine, 18x24 inches.

Figure 4-5.
Point Reyes Light, 14x21 inches.

Figure 4-6.
Misty Day, 18x24 inches.

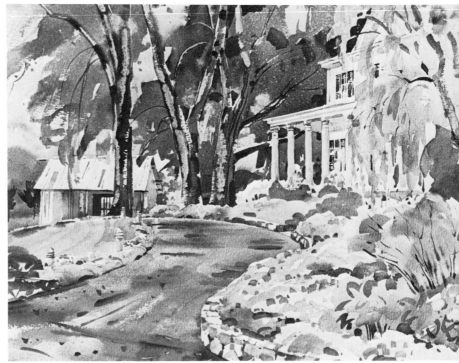

Figure 4-7.
Tomales Sky, 18x24 inches.
Collection Mr. & Mrs. Walter Oertel.

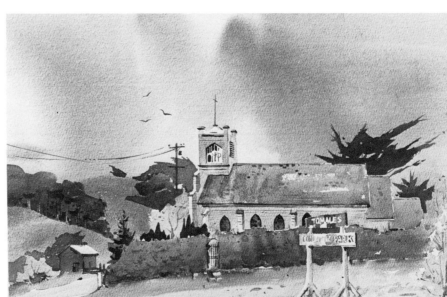

Wet-into-Wet

Working on a sponged or wetted paper will allow a more spontaneous and inventive means of expression. It is necessary to use a more concentrated color, as the wet surface will dilute the pigment. When wetting the paper, you can leave a few dry areas to provide a glint of white here and there after color is applied. In the picture of the lighthouse (Figure 4-5), I painted a mixture of Winsor blue and permanent rose across the top of the sponged paper and allowed the paint to run down and blend into the wet surface. Next, a mix of Winsor blue warmed with burnt sienna was painted with wide vertical strokes, and also allowed to blend. I added patches of Winsor green to the moist paper and then stronger notes of color before the paper started to dry. Finally, I painted brushstrokes of raw sienna and manganese blue on the lower portion of the sheet.

Blending Washes

When a scene requires the blending of a variety of shapes, I often use two brushes. Paint is applied to the dry paper with one brush and then clean water is quickly applied to the desired edges with the other. This allows the color to blend and diffuse and I don't have to rinse the brush again and again as when I'm painting with only one brush. To paint the effects shown here (Figure 4-6), I used a combination of blending and dry brush. The large leaf patterns and sky areas were roughly washed in with a 1-inch flat brush and then blended with clear water with a second 1-inch brush. Leaf masses are fun to do and easy to control when using two brushes in this manner. Some of the leaf masses were also dry brushed, as were the large tree trunks and limbs.

This scene was painted from the open doorway of a nearby barn during a light drizzling rain. I wasn't completely sheltered, and the rain caught the top edge of the paper, creating additional textures in the leaf masses.

Controlled Wet-into-Wet

If you want to quickly paint a number of elements of a scene wet-into-wet but don't want the various shapes to run together, you need to leave a very small white line between them. Color can be controlled in each area before you move on to the next one. The effect is more lively than if you carefully glazed flat washes over the entire sheet. (Sometimes, of course, color can be controlled more easily by turning the sheet in the direction that you want the color to flow.) If the white lines that separate wet-into-wet passages appear too prominent, they can be subdued with a light value of a neutral color after all washes have dried.

The watercolor *Tomales Sky* (Figure 4-7) was painted as an on-location workshop demonstration. The paper was first moistened with a large brush, but only down to and around the church building, which was left as dry paper. The oncoming rain clouds were then boldly painted into the wet paper and the colors allowed to blend without further brushing. The rest of the scene was painted wet-into-wet in separate controlled areas.

Brush Handling

Painting on location requires quick and decisive control of the brush. Everything is constantly changing, and it takes a quick brush to capture the fleeting shapes and patterns around you. The spontaneous effects of a painting done on location are greatly enhanced by the skillful use of the brush. Versatility with the brush can, of course, be achieved only through practice.

Having the right amount of water in your brush is important, not just for laying washes but also for achieving different brush effects. Too much water can cause washes to get completely out of control, while too little water will create a hard, dry brush effect that doesn't allow the medium to express its fluid transparency. To control the brush's moistness, squeeze some of the excess water or paint from it with your fingers or press it lightly on a paper towel or damp sponge. A good amount of premixed color is necessary when laying a large wash. Keep the colors on your palette moist by squirting water onto them from an atomizer or ear syringe, or flicking it on with a large brush. This will allow you to quickly add paint to your premixed puddle or to change its hue, value, or intensity.

The texture and weight of paper as well as the kind of paper used greatly influence the effects that can be achieved with brushwork. Some papers are more absorbent than others. Hot-press papers, because of their smooth surface finish, will not allow the watercolor to be absorbed as readily as cold-press or rough papers.

The slant of the paper also affects the color and the brushwork. A horizontal sheet will allow more color to be absorbed, while on a vertical sheet the color will run down the paper and values will dry much faster and lighter. When you work with a horizontal or nearly horizontal paper, the excess water that gathers at the edges needs to be wiped off with a tissue; otherwise the moisture may run back into the washes.

Variety of Brush Techniques

Don't just practice with your brushes—try to have fun with them at the same time. You will find that a variety of thick-thin, in-and-out lines, and crisscrossing brushstrokes can not only define form but also create excitement with interesting intervals of light and dark. Good subjects for brush practice are those that have pleasing, flowing detail, like the tree forms in the sketch *Coastal Pines* (Figure 4-8).

View trees against the light and you will discover that in some areas many of the intricate limbs and branches are combined into large silhouettes, while in other areas the limbs are revealed as a fine tracery of interlacing lines. To capture these effects with both large and small brushes is a challenge as well as a fun exercise. In some of the larger limbs you can scrape light values or thin lines out of the wet paint with a brush handle, knife, or razor blade. If the paint is too wet, then color will run back into the lines and cause them to become darker. Try scraping into paint during various stages of drying to become familiar with this technique and the fine effects you can achieve.

Figure 4-8.
Coastal Pines, 21x14 inches.

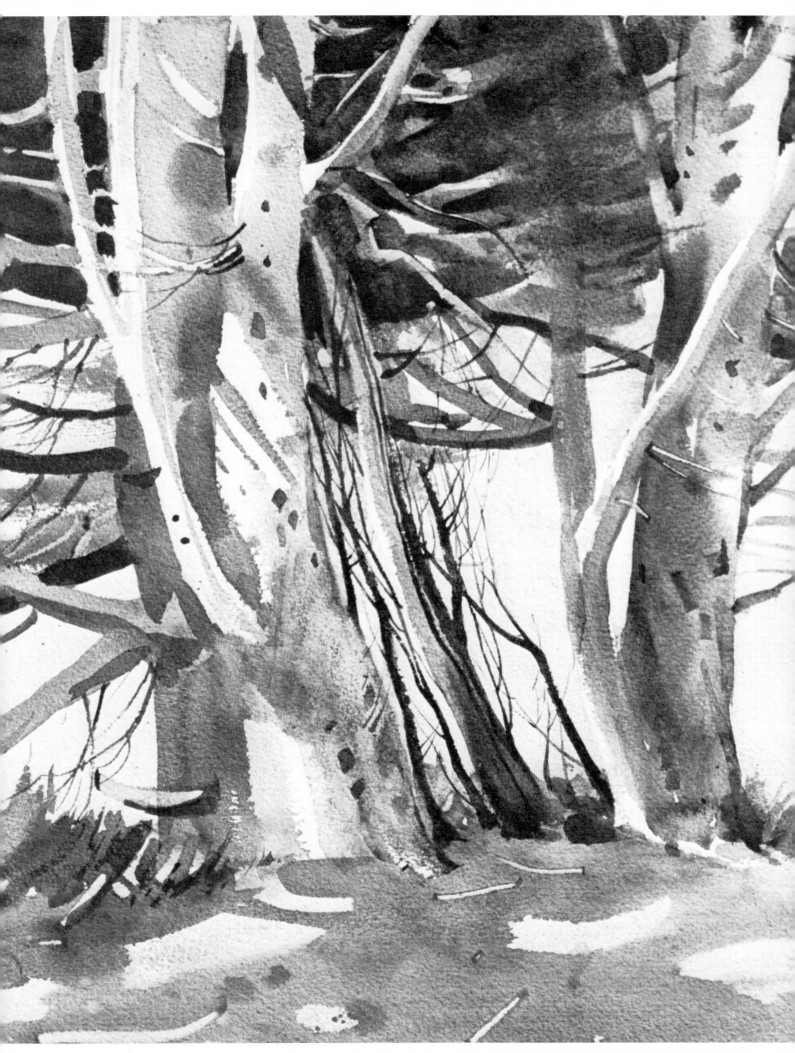

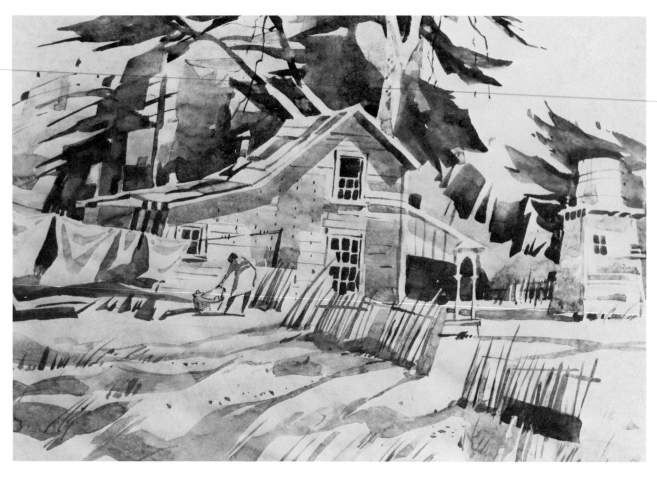

Figure 4-9.
Coleman Valley Cabin, 18x24 inches.

Bold Statements

The broad strokes of a 1½-inch flat brush helped to eliminate detail in the sketch *Coleman Valley Cabin* (Figure 4-9). Rhythmic sense of movement is implied through the vigorous twisting and turning of the brush. The lines of the fence as well as the boards on the cabin were stamped in with the edge of the flat brush. A No. 6 script liner or rigger (a long pointed sable or white nylon brush) was used at the end to enrich a few of the large wash areas and to describe hanging limbs.

For a loose, rhythmic movement, brushes should be held lightly toward the end of the handle. This will also help to create an unlabored effect. For precise work the brush should be gripped closer to the hairs. The key word here is practice. You have to acquire control of the brush before you can develop an expressive watercolor technique. Your brushes will become good performers if you take them out and practice with them a bit every day.

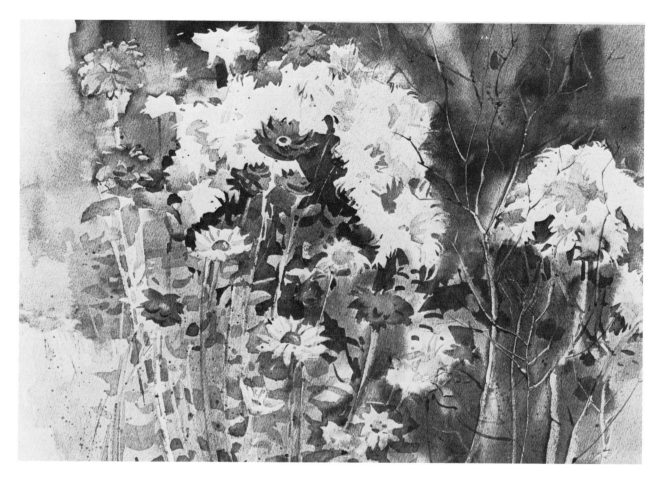

Figure 4-10.
Autumn Palette, 18x24 inches.

Intricate Brushwork

When complex shapes and detail intertwine as in the painting *Autumn Palette* (Figure 4-10), try *drawing with the brush*, gradually working from large shapes to small, from soft edges to hard, and from light values to dark.

The initial large background washes were painted directly onto a dampened paper with predominantly cool colors, leaving areas of white. I then introduced darker tones, with a variety of blues and browns, into the first washes while they were quite wet, allowing colors to mingle on the paper. To provide a contrast with the cool background, I brushed a few warm light-value yellows and red-violets into some of the white areas and let them blend on the moist paper.

As the paper started to dry, I painted darker tones with increased variety next to and around some of the flower shapes. Both flat and round brushes were used to define the ragged edges of petals and leaves. Some edges were softened by the moisture in the paper. Stems were scraped into the paint before it dried.

Finally, intricate brushwork was used to add and define flowers and leaves. Some of the leaves were painted with middle tones over light areas while others were painted in reverse with dark flat values around and behind the leaf and flower shapes.

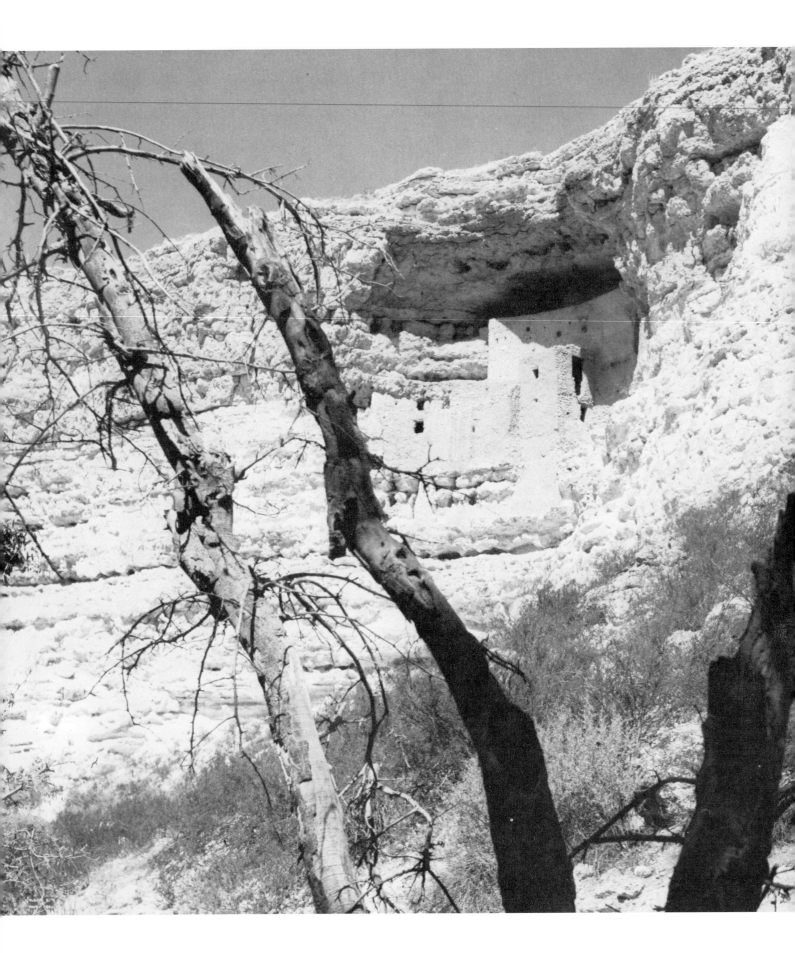

FIVE

Figure 5-1.
Photo of Montezuma Castle National Monument, Arizona.

Selecting Subject Matter

Any painting must start with an idea or with the selection of subject matter. Artists may sometimes have difficulty deciding what to paint. Things that attract one person may not be of interest to another. I think any scene that awakens my interest is worth a try.

It isn't always necessary to seek new subject matter. Going back to familiar motifs enables you to reach a higher level of personal involvement. The light is never the same each time you go back. Morning light, noon light, or afternoon light may reveal patterns that you hadn't noticed before. Seeing a familiar subject in a new light is often the key to a successful painting. Naturally it's best to choose a subject or a viewpoint that will allow more than a routine kind of view.

Some subjects are ideally suited for a spontaneous wet-into-wet treatment while others require a careful analysis and buildup of washes and glazes. Painting procedures are frequently determined by the subject matter you choose. The movement of breaking waves, for example, would suggest a free and loose handling.

Traveling to foreign lands in search of subject matter can be both stimulating and visually exciting, but you don't have to go that far to paint a successful watercolor. Most artists can find sufficient material in their own locality to last a lifetime.

Figure 5-2.
Point Bonita, 21x15 inches.

Painting in State and National Parks

There is no substitute for going to nature, not just for inspiring subject matter but also for the discovery of intriguing new color, mood, and texture. The coastal parks of northern California are stimulating and have provided me with much excellent painting material. Here, at the edge of the continent, on a bluff overlooking the Pacific, I often set up my easel. With the sun and wind in my face and spongy bed of vegetation beneath my feet, I have painted some of my favorite watercolors.

Every state has its share of scenic parks, preserved for the enjoyment of mankind. County, state, and national parks offer you a quiet, pleasant atmosphere for painting a large variety of subjects that include trees, water, rocks, surf, and scenes of historic significance. Entrance fees are nominal and some recreational areas even allow the public in without charge.

The watercolor *Point Bonita* (Figure 5-2) was painted from the Marin headlands of the Golden

Gate National Recreation Area. It's a wonderful location, offering commanding views of the Golden Gate and the city beyond.

The day I painted this scene the sound of surf and seabirds filled my ears, and the dampness and the wind spurred me on to begin a composition. Then, watching giant oil tankers going out to sea, I stopped work for a few minutes. My interest in my composition was renewed when I spotted a number of sailboats tacking a zigzag course beyond the Point Bonita light. The motion of the boats provided a counterpoint to the more static foreground.

The view from the headlands here is so encompassing and magnificent that you are tempted to put it all down, yet you know from past experience that trying such a feat usually invites disaster. You need to focus on only a portion of a busy scene.

Painting on Private Property

Appealing subjects are most often discovered along the backroads and off the freeways. Even here it's wise to find a painting spot that is away from local traffic. Parking on the side of a road that is well traveled is not a good idea—kind souls stop to see if your car is broken down or if you need help of any kind. Many fine subjects can be found on private property and they afford a variety of viewpoints. But you should always get permission before you begin to paint. Most owners will be pleased with your courtesy and will be flattered that you chose their place as a subject for a watercolor. Quite often they may be interested in buying your painting.

Inspiring Locations

The best views and the most inspiring painting spots are found in locations away from busy roads. Here you have an opportunity to study your subject more intimately and carefully—and to paint with fewer distractions.

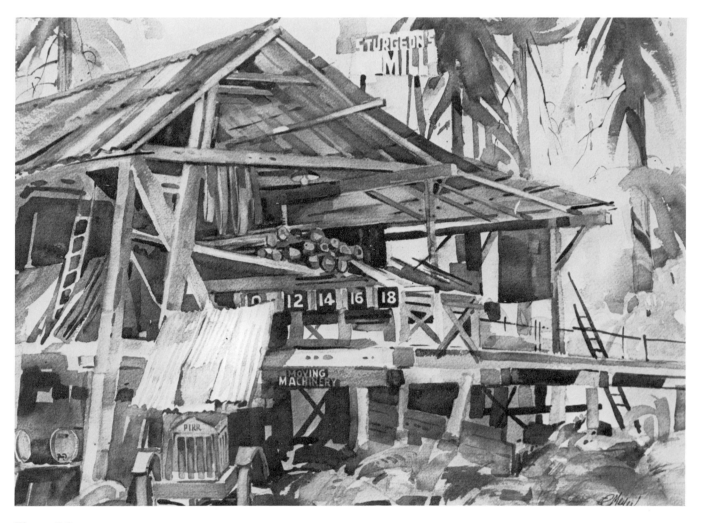

Figure 5-3.
Sturgeon's Mill, 18x24 inches.

The Disappearing Subject

Watercolor painting requires terrific concentration, so it's easy for something unforeseen to happen before you quite realize you have a problem. Once, while I was painting near a railroad siding, a long freight train stopped for over an hour, totally obstructing my view. When it finally left, all the values of my subject had completely changed.

Of course I try (and so should you) to be on the lookout for things that affect my picture—for example, when the sun will provide the best shadows or when the tide will be low. If you paint along the coast, bring along a tide table to help you plan ahead. The boat up on the ways that you are painting is usually launched during high tide. If a boat has a new coat of paint and the tide will soon be rising, don't choose it as a subject unless the owner tells you he won't launch that day.

I recall the time I had decided to paint a newly renovated pleasure boat up on barrels. Certainly a secure, immobile subject, I thought. Yet just as I was applying some nice juicy washes, a large semi-trailer backed up under the boat and hauled it away, leaving me with a large sky. Perhaps that's one reason I search out shabby, forlorn subjects. They are not likely to be going anywhere.

I recall another time while painting the D Street drawbridge in downtown Petaluma. I was deep in my washes when the customers dining at an outdoor cafe across the river started waving and shouting, "There's a man lying down there by the water—is he all right?" I couldn't ignore their continuous shouting so I left my easel and went down to investigate. Sure enough, there was a man lying there, but he was a wino, sleeping it off while the tide crept up on his legs. I tried to shout this information back across the river but the people apparently couldn't understand me or didn't believe me. They finally summoned the police, who came and hauled the man up the river bank and escorted him out of town. Meanwhile, with all the distraction, my washes had become a real mess.

If you work in your studio you may have a less hazardous time, but I prefer to have my subject right there in front of me, even though my results are sometimes disastrous. The few distractions I've had to contend with are nothing compared to the satisfaction of seeing my painting come to life through the wonderful effects of natural sunlight and shadow.

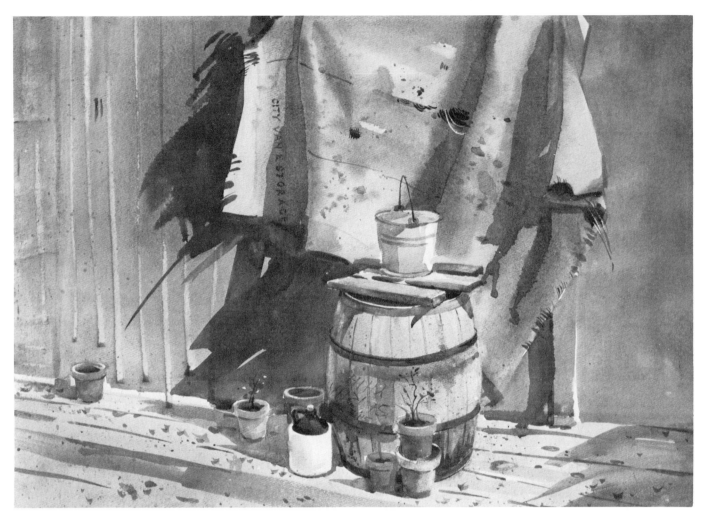

Figure 5-4.
Rain Barrel, 18x24 inches. Collection of the artist.
After a long January rain the sun finally came out and
surprised me with these exciting shadows.

Painting in Your Own Backyard

As I've already pointed out, it isn't necessary to travel to faraway places to find material for your watercolors. Exciting subject matter can usually be found right in your own backyard. Pine branches, autumn leaves, buckets, thistles, melons, chickens, farm implements, and countless other things have been the subjects of successful paintings. If you are in search of something different, try looking in at a yard sale or stop down the street in that *empty* lot. You can also find new inspiration and new compositions by looking out toward the light through windows and open doors.

The inside of an old barn can provide interesting compositions. Missing boards here and there, leaning angles of timbers, and strong patterns of light and dark seem made to order. Reflected light, bouncing in through open areas, creates many subtle value and color changes. Again, much of the excitement of watercolor painting is in discovering new shapes and patterns and in the challenge of making them work.

SIX

Planning the Painting

When nature presents you with a captivating variety of shapes wherever you look, you don't want to fail in capturing the rhythm and beauty of your subject. But, confronted with shifting patterns and an abundance of detail, you may forget the need to unify the elements of the scene.

Good space division and arrangement of shapes and values must be accomplished if you want to make a forceful statement and a strong painting. Studying the subject from different angles will often help you discover the best viewpoint, as well as design elements you can use to structure a more energetic picture.

Bear in mind that painting a watercolor is not a problem of capturing the scene as the camera might see it. Your composition must have something in it that can be enjoyed apart from its subject.

I tried several different views of a subject I have already mentioned, the D Street drawbridge in downtown Petaluma. I felt this downstream view (Figure 6-1) resulted in a scattering of elements across the paper. I did another painting of the same subject from a sidewalk approach (Figure 6-2), which allowed me to develop a more exciting composition. Immediacy and a cohesiveness were achieved by moving right in on the scene and using overlapping elements. Including several colorful signs perked up the interest.

Figure 6-1.
Downstream View of D Street drawbridge.

Figure 6-2. D Street drawbridge, 18x24 inches.

Figure 6-3.
Photo of subject and value plan.

The On-Location Viewpoint

The viewpoint you choose can play an important part in the success or failure of a painting. Rather than paint your subject from the first view you see, try to find a view or an angle that will lead the observer's eye into the picture and on to an interesting feature of the subject. When you walk around your subject, keep your eyes open for a pleasing grouping of values as well as an uncluttered, open lead-in. Sometimes, of course, your view may be rather limited, but usually you can back away from or close in on the scene enough to allow a good selection of design-making elements. On some occasions it's advantageous to select only a portion of a scene so you can avoid a scattering of elements.

How to See Your Subject

Once you have decided on a spot, don't be in too much of a hurry to start splashing color onto the paper. Look the scene over carefully and get an overall feeling of the place, its color, mood, and abstract qualities. Try to see your subject as a series of simple, flat areas of tones. See if these can be arranged in a well-balanced display of both warm and cool colors.

Observe the shadow areas, too, and the color within them. The way shadows play across your subject can have a great influence on the design and mood of your painting.

Instead of allowing tones and patterns to become scattered within the picture area, as they often are in reality, you need to combine them into a minimum number of alternating patterns of light and dark, with middle values tying these together. What you are seeking is a designed unity in which the lights and darks interweave throughout the composition.

Figure 6-4.
Three-line grid.

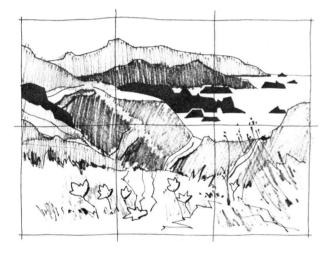

Figure 6-5.
Value contrast.

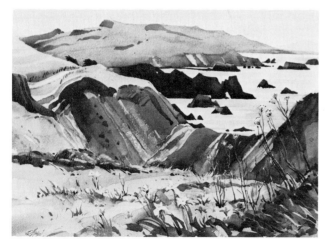

Figure 6-6.
Sonoma coast, 18x24 inches.

Placing the Subject

Before penciling in my subject on the watercolor sheet I often make a preliminary sketch in black and white on a sketch pad, using charcoal, a soft pencil, or a felt pen. This helps me to be sure that the values I see have good design-making qualities and are placed in the sheet with a pleasing flow of light through the middle tones and darks. Sizes of the sketches are of the same proportions as the watercolor paper and vary from small thumbnails to 9x12 inches, as shown in Figure 6-3. I wanted the photo to show both my subject, the distant headlands, and my sketch, which looks bigger in relation to the subject than 9x12 inches because I wasn't able to step back as far as I would have liked. (This prompts me to offer a word of caution: when painting in precarious situations, always look behind you before stepping back!)

A three-line grid—two lines vertical and one line horizontal—is drawn on the sketch paper to help establish a good balance and placement of the subject. The horizontal line is a reminder not to place important elements of the subject on or too close to this center line. The main point of interest can be placed near one of the vertical lines, with supporting interest somewhere near the other vertical line. Transferring the sketch to the watercolor paper is made easy by drawing a three-line grid on it, too, using a No. 2 pencil. A grid with more lines can be used but I have found the simple three-line grid to be sufficient. The lines, if lightly drawn, are easy to erase after the watercolor has completely dried.

When I start to sketch my subject I'm not concerned with descriptive detail, but do the obvious first and seek out contrasting values and large shapes (Figure 6-4). I look for an intriguing grouping of things in the center of interest and then gradually add larger, less distinctive elements as I work my way outward (Figure 6-5). The most important part of my picture is established in my sketches, with darkest darks next to the lightest lights, which are then surrounded by middle values. The overall design, pattern, and rhythm of my composition are determined at this time.

When painting the watercolor I start with the light tones and work my way up to the darks, using my value sketch as a guide (Figure 6-6).

Space Division

You can achieve good space division by dividing the sheet into unequal areas with both horizontal and vertical lines. The main elements or shapes of the subject are distributed along these lines, but you must be careful to adjust the edges of large shapes so they are not in line with the center of the sheet, either horizontally or vertically. The trouble with basing the structure of a painting entirely on rectangles is that the painting can be dull and monotonous. Some relief is needed in these areas.

Figure 6-7.
Space division.

The composition immediately becomes more exciting when some of the monotonous lines are slanted or tilted. Angles and diagonals create tension and can put life into the painting. Along with an exciting structural foundation, the placement of subject matter needs to be well throught out or the painting can become very disturbing. How many times have you looked at a picture that seemed off-balance? Usually you can straighten the matter out simply by balancing a large object with one or two smaller objects farther away from the center.

Figure 6-8.
Tension.

We must establish a good balance of values before we even think of adding detail in trying to explain the subject. Our intuition tells us that a large dark shape outweighs a smaller one and commands more attention. This is especially true when we are dealing with dark subjects on a light background. On a dark background it is the large white shape that outweighs the smaller white shapes.

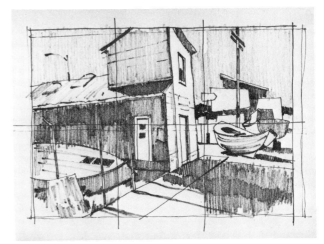

Figure 6-9.
Value balance.

64

Minor Shapes

When I painted this scene I became involved with an intricate combination of minor shapes which seemed necessary to produce the kind of picture I wanted. This resulted in a scattering of distracting light areas. Later I glazed these over to allow the areas of extreme contrast to command attention.

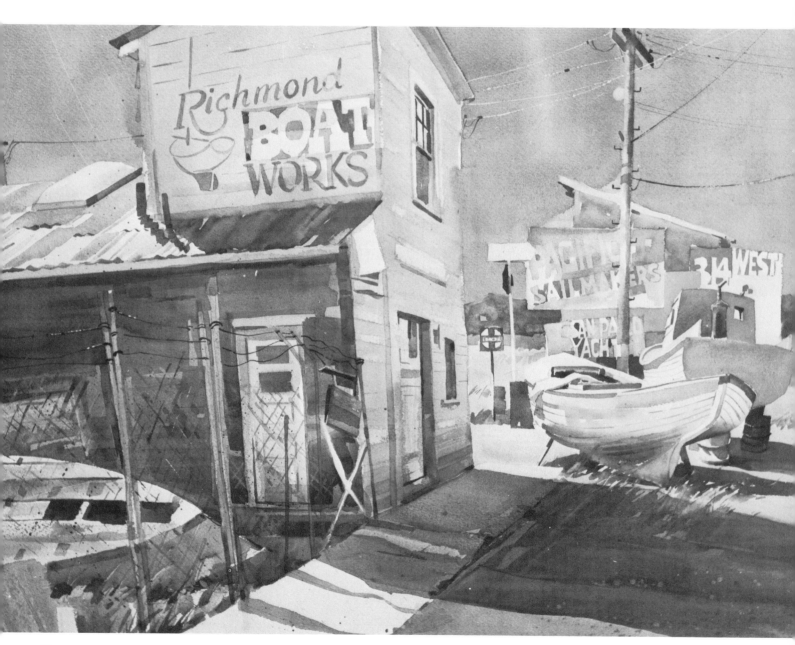

Figure 6-10.
Richmond Street Corner, 22x30 inches.

Value Patterns

The successful watercolor is most often the result of maintaining a big value pattern. When you first walk into an art exhibition, usually several paintings command attention, and you are immediately drawn closer to examine these before looking over the rest. Up close, you see that the large patterns are broken into numerous smaller value patterns that please the eye as they describe the minor shapes and details of the subject. When you step back, all of the smaller patterns seem to fall into three major value patterns—dark, middle, and light.

Whatever your subject, the arrangement of values into an artistic form is a strong element in successful watercolor painting. White patterns on a mid-dle-tone field command attention. Placing darks next to whites creates a maximum focal point. This is a key factor to be considered when designing your picture.

In the simple value sketch of a few flowers (Figure 6-11), notice how attention is focused where the small, dark shapes overlap the large white area. Once the main value pattern has been established, any number of subtle values can be introduced without destroying the large overall pattern.

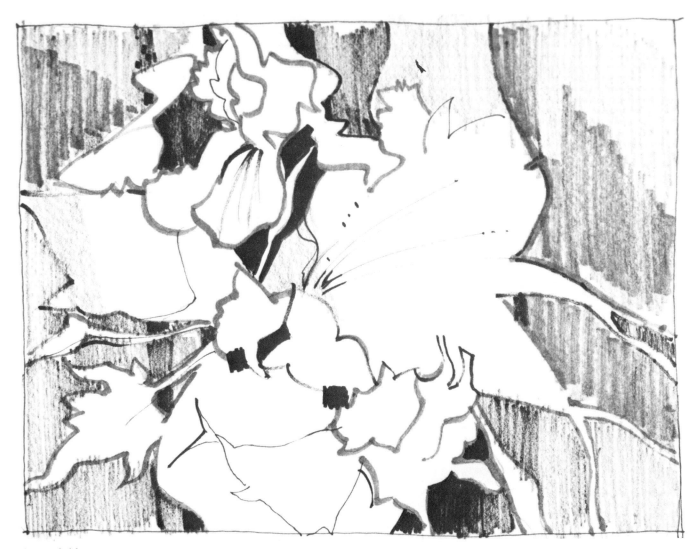

Figure 6-11.
Value patterns.

66

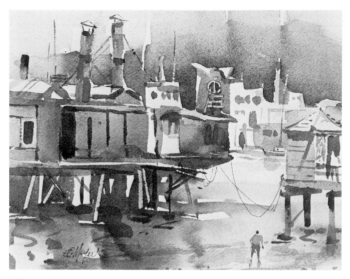

Figure 6-12.
Houseboats, 8x10 inches.

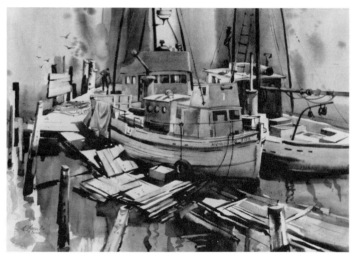

Figure 6-13.
Petaluma Tie-up, 22x30 inches.

Figure 6-14.
Sunday Morning, 18x24 inches.
Collection Dr. & Mrs. Gilbert Barron.

Balance of Patterns

The well-balanced negative and positive patterns in *Houseboats* (Figure 6-12) were simplified by *zooming in* on only one section of a busy and complicated waterfront scene. Shapes were painted without outline. The large white shape of the distant houseboat is balanced with smaller pieces of white between the pilings in the left foreground. A few dark pilings at the right echo the large dark patterns of the near houseboat.

This painting of a dilapidated wharf (Figure 6-13) is shown in an unfinished state. While the varied patterns of positive shapes and negative passages help to lead the eye into and around the picture, the overall design is much too spotty. The darks and lights are too isolated and cause the eye to jump around. Glazing over some of the light areas will make the painting more pleasing.

In *Sunday Morning* (Figure 6-14), a painting of my daughter reading the Sunday paper, the lights are tied together into one unit that allows the eye to move up and into the center of interest. Minor whites in other areas of the composition serve to balance the large white shapes of overlapping newspapers. The darkest darks help to set off the middle tones (Figure 6-14).

Capturing the Essence of a Scene

When a scene stops you and makes you want to get out your sketch pad or set up your easel, there is usually something special about it. Even so, it can be difficult to capture the uniqueness of the scene because you may get sidetracked by unnecessary elements and lose the main theme. While painting the subject, you need to ask yourself what made you stop there in the first place, and what are you trying to say?

Sometimes a painting depends upon a splash of brilliant color to focus attention, but mood, balance, rhythm, and a good value structure are still most important. Occasionally you may be fortunate enough to find a subject where the picture-making elements are perfectly arranged, but don't count on it. More often than not you need to rearrange some of the elements so that attention is focused on the aspects of the subject that caught your eye at the start.

How Much to Include

It's always a great temptation to put in everything just because it's all out there in front of you. To avoid this you need to be selective and search out those things that will help you structure a strong composition. If you put everything you see, exactly where you see it, you are taking a chance on weakening the design. Search instead for the elements that will make a strong impact on the viewer. If part of the scene doesn't help the composition, then it is better to leave it out. Try to avoid a literal viewpoint. Be inventive. Convert the bare facts into a beautiful composition without changing things so completely that you lose the character of the subject.

Compare the photo of the shoreline scene shown here (Figure 6-15) with the watercolor I based on it (Figure 6-16). It is readily apparent that I took a number of liberties. I worked to make the painting more effective by relating each part to the next with a dark-light value alternation. The arrangement of the foreground leads you right in and up to the two figures. The composition is designed so that the eye follows the white shapes up and across, and then back down to the rickety shack and the figures.

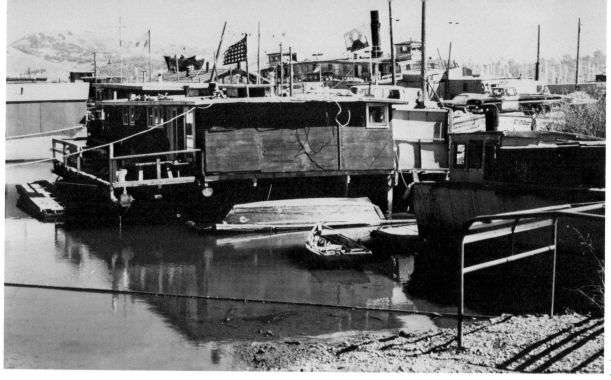

Figure 6-15.
Photo of subject.

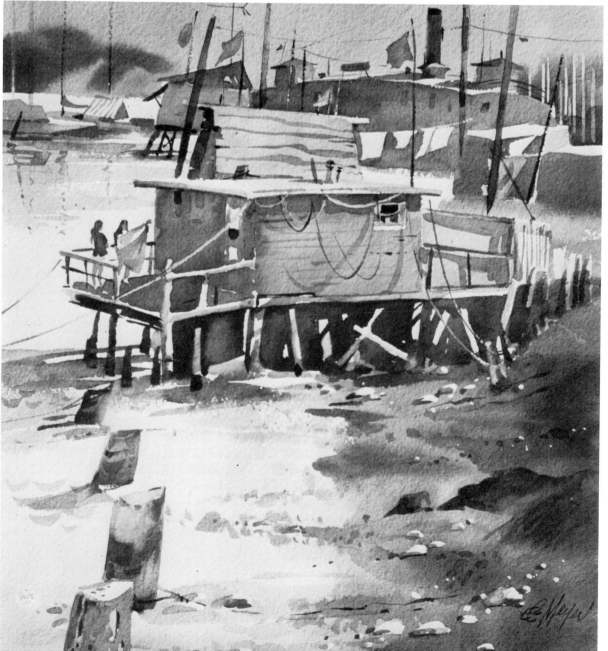

Figure 6-16.
Sausalito Shore,
18x15 inches.
Private collection.

Figure 6-17.
Old Winery, 18x24 inches.

Setting Up Tension

A variety of tones and patterns is created when light falls on different earth planes and objects. These are seen as flat tones and can be used as building blocks to structure your design. But a picture is static if these tones are all of the same size, or of the same value, or if they are all vertical or all horizontal. You need to vary the sizes and the spacing, or make them lean a bit. Then the patterns and tones will react with one another and give the picture energy and excitement.

You can set up a tension by tilting or putting things out of line, just as they occur quite frequently in real life, particularly in old structures, as in *Old Winery* (Figure 6-17). First you carefully size up the scene—its whites, the lightest areas, and its placement on the paper. Then, by holding a pencil over a cardboard viewfinder, you can determine the angles and thrusts of the subject.

To keep the subject from tipping over and to maintain the composition in balance, counterthrusts need to be sought out and used. In this painting the opposing shadows along with the leaning fence

react vigorously with the slanting boards. This variety of opposing forms actually occurred in the scene itself. When necessary, however, the forms of placid scenes can be exaggerated in order to generate a more lively composition. Again, a pencil held across the opening of a cardboard viewfinder (Figure 6-18) helps you to approximate the angles of rooftops and leaning structures and to judge whether you need to change them to give your picture the animation you want.

Figure 6-18.
Sizing up the scene.

Figure 6-19. Santa Rosa City Limits, 18x24 inches.

Maintaining a Center of Interest

Often a painting has so many objects scattered through it that we don't know where to begin to look. It's much like walking into a country hardware store where so much is displayed we sometimes forget what we came in for. Perhaps the most difficult part of painting a watercolor is to maintain a center of interest. Even after careful consideration and planning, and with our idea sketched lightly on the paper, we get so carried away with the beauty around us, once we start to paint, that we lose track of our original intentions. It's important to concentrate on the dominant things that caught our eye in the first place.

A center of interest should not be bunched up as a target, but needs to be referred to with diminishing emphasis throughout the painting. Sometimes you can do this by echoing shapes or lines, or by repeating elements in a diffused manner.

In transparent watercolor, unlike other painting mediums, it's difficult, if not impossible, to completely wipe out or cover up things that later on are found to compete with your original concept. From the time you first pencil in your subject, and on through the painting process, it's important to keep in mind where you want to focus the viewer's attention. You can't go back. To avoid these problems, study your painting from time to time with a mat placed on it.

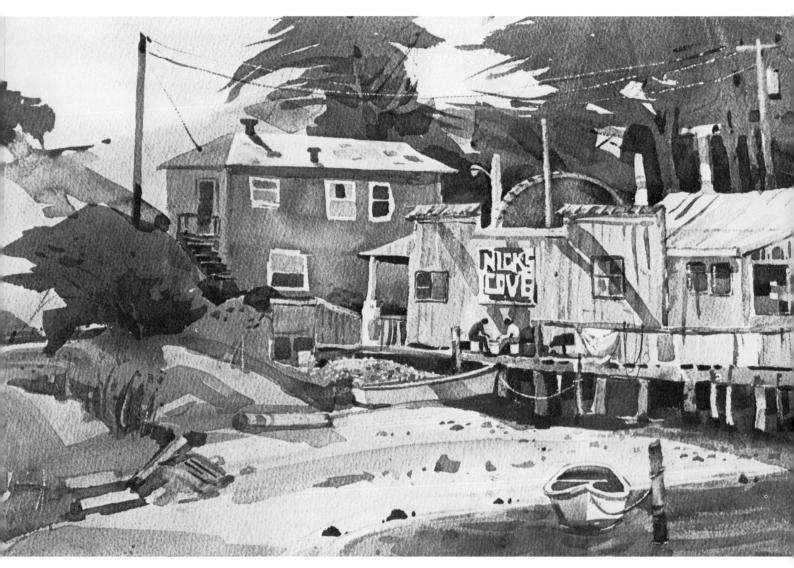

Figure 6-20.
Nick's Cove, 18x24 inches.

Interest

Your center of interest needn't be emphatic, but it should be carefully planned to draw attention. In this scene, notice how your eye keeps going back to the two women on the wharf who are busy shelling shrimp. They seem inconspicuous at first glance, but they are the center of interest and all other elements merely play a supporting role.

Containment

Lines are used in the real world to tie up bundles of various items. In pictures, some of us carry this too far and make the mistake of wrapping lines around all of our wash shapes, thereby preventing them from flowing or blending into one another. We need to retain "lost and found edges." These are the elements that tie shapes together and at the same time allow the eye to travel through the picture.

A composition can also be tied together through the use of repetition. I often seek out an important directional thrust and then look for places to repeat that thrust, to give a consistent rhythm to the design. These thrusts should not be all of one thickness but should consist of a variety of brush strokes, both thick and thin. Maximum attention is gained with wide strokes, like those used to paint the shadows of the bell tower in the sketch (Figure 6-21) shown here. The lines and shadows on the tin roof of the adjoining building, as well as the shadow cast by the sign, repeat and continue this movement into the vertical lines of the picket fence at the right. The slanting thrust set up by these shadows also continues in the sky, where I deliberately created it—not only as a repeat but also to integrate the sky with the rest of the composition.

Repeats of a variety of lines and shapes exist in nearly all subject matter and should be sought out. The long repeated shadows that we see early in the day or in late afternoon, undulating across the landscape or across man-made structures, can be very useful in tying a picture together.

Also, as we saw previously, the lines used to form the grid on which we build our composition are not explicit. Still, they exert an influence on the shapes that they support. This influence is often noticeable when lines or edges of shapes seem to lose themselves as they jump across certain passages and then reappear as they continue to define other shapes within the composition. These lines can be likened to the threads in a woven fabric, where you see them disappear, then reappear, linking together colorful shapes.

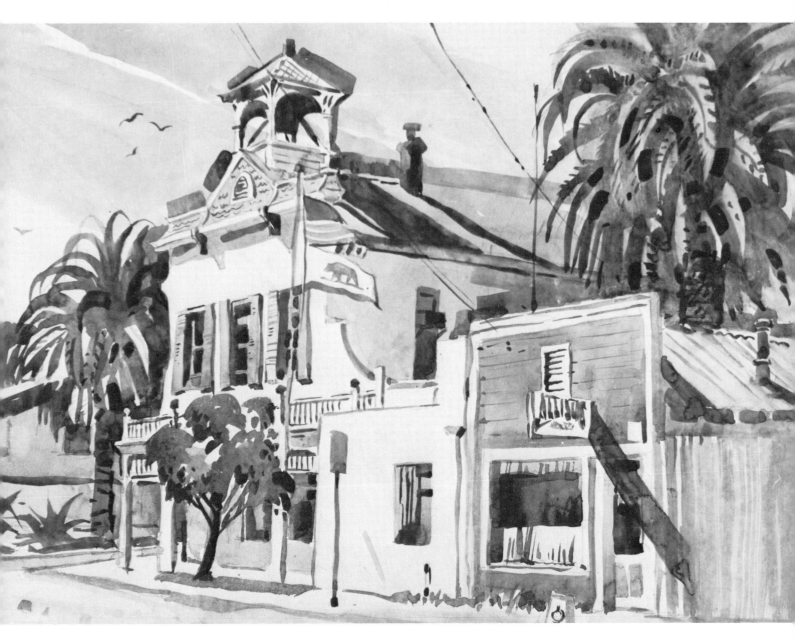

Figure 6-21.
Value sketch of Calistoga City Hall.

Repeats

This large value sketch, 18x24 inches, was made on inexpensive white wrapping paper. The repeating lines, both curved and straight, do more than tie the composition together; they also set up a feeling of movement. Notice how the lines occasionally stop, leap over a passage, and then continue their course, linking up shapes.

Perspective and a Point of View

How we use perspective to portray a scene depends on our point of view. Most artists are familiar with perspective and its terminology—eye levels, vanishing points, horizon lines, and so on. I don't believe, however, that we should adhere strictly to linear perspective as it can create too much of a "target." Nor does it allow for a decorative use of forms and shapes. Yet, while much creativity stems from a personalized use of perspective, it's sad to see an otherwise good painting spoiled by lines and shapes going in wrong directions.

Perhaps the least understood principles are those that involve multiple viewpoints. To make objects look convincing, especially buildings, they need to be drawn in the right perspective. All receding lines of objects below the horizon line will go *up* to a vanishing point on the horizon or eyeline, as it is often called, while all lines of objects above the horizon line will go *down* to meet the eyeline.

The sketch of San Francisco Bay (Figure 6-22) has several vanishing points. One is on a high eyeline, above the distant shore and centered on the mountain, near the top of Alcatraz Island. All lines of the buildings converge at this point. The other vanishing point is on a low eyeline, behind the cable car, where rails and curb lines converge. In this scene an illusion of going *downhill* is created.

Figure 6-22.
Looking downhill (high eyeline).

Figure 6-23.
Looking uphill (low eyeline).

In the sketch of Kearny Street Hill (Figure 6-23),
an *uphill* illusion is created by placing the normal
eyeline very low where the lines of roofs and win-
dows converge. The lines of the street, however,
converge at a high point, in the sky to the left of
Coit Tower.

It can be seen in these two illustrations that the
eyeline moves up or down with you as you climb
up or down these steep hills. It is possible to have
many converging points in one picture.

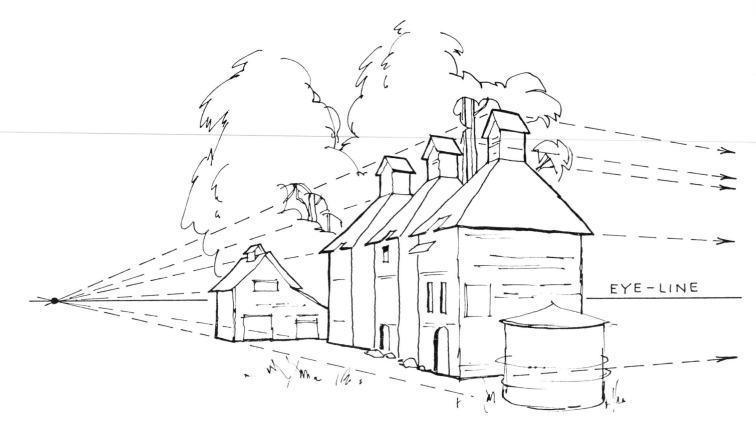

Figure 6-24.
Perspective diagram for painting of hop kilns.

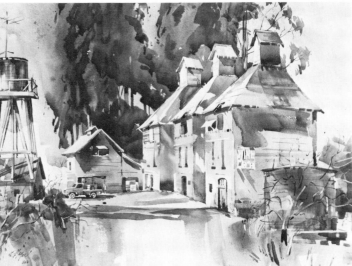

Figure 6-25.
Hop Kilns, Forestville, 22x30 inches.

Vanishing points are often out beyond the picture area. When this occurs you need to imagine the location of vanishing points on an eyeline and have your receding lines converge at these imagined points (Figure 6-24). Another method, mentioned earlier, is to hold a pencil or brush handle parallel to the roof lines, window lines, or other lines of your subject, and then simply transfer this angle to your watercolor paper. It isn't necessary to spend too much time doing this as you can readily tell if the perspective looks right. While some composi-

tions owe their uniqueness to planned distortion, your concern here is to use the principles of perspective so that what you see looks right when placed on the watercolor sheet.

In the value sketch of a street scene (Figure 6-26), all lines converge at a single point behind the Wine Inn sign. Also, all objects diminish in size as they extend back. In this perspective point of view, the eye could rush in quickly to a central target. It becomes necessary to spread interesting shapes and values around through the composition so the van-

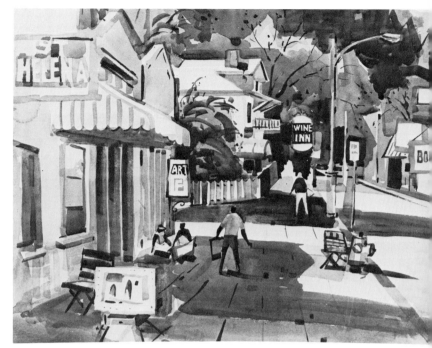

Figure 6-26.
Value sketch of a street scene.

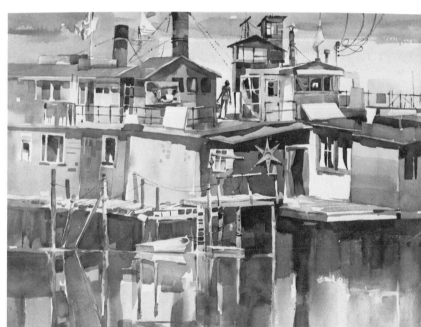

Figure 6-27.
Marine Painter's Studio, 18x24 inches.

ishing point does not become a target. The figures
and the signs in this picture help to slow the eye.

In contrast, all of the windows and walls of the
numerous structures in the painting *Marine Painter's
Studio* (Figure 6-27) are facing you squarely on a flat
picture plane. The many rectangles and their reflec-
tions were deliberately composed with a value
structure that leads the eye gently throughout the
picture. The painting makes use of alternating dark-
light patterns as part of the design.

SEVEN

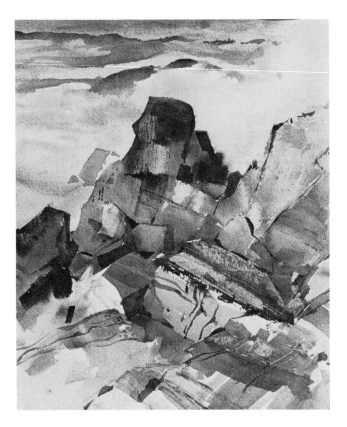

Figure 7-1.
This section of the painting at right (Figure 7-2) shows how colors appear when photographed in black and white. It emphasizes the importance of a good value structure.

Seeing Color

The colors that we see in nature and in our environment vary from subtle, elusive nuances to bold and brilliant displays that encompass the entire spectrum.

When we're working outdoors the eye will often see color that is hard to define and impossible to reproduce. Since we have only paint and paper with which to express ourselves, we must take liberties and work with approximations and exaggerations of what we see.

A colorful painting is not one that displays all the colors on our palette but one in which color is carefully selected to portray certain effects and maintain a pleasing harmony. Usually only a few warm colors played against a few cool colors are necessary to simulate the effects of nature.

Also, the right value relationships of color (of light against dark), will tell more about our subject than its descriptive features alone. Values create the accents we need to simulate the radiance of sunlight and shadow.

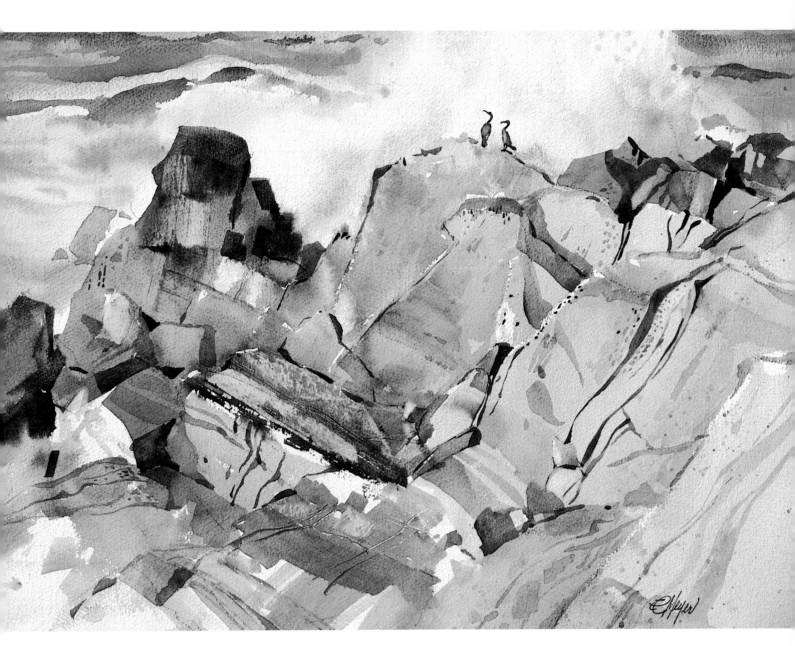

Figure 7-2.
Surf at Salt Point, 18x24 inches.

Setting the Palette

The colors of nature's spectrum, as seen in the small cross section of the rainbow at bottom right, are arranged in a similar sequence on the palettes below (Figure 7-3). The warm colors have been placed in the wells of the top palette and the cool colors are opposite these, in the bottom palette.

Placing complementary colors (those opposite each other on the color wheel) also opposite each other on the palette greatly simplifies color mixing. Note that the earth colors—the ochres, siennas, and grays—are grouped together on the left-hand side of the palette.

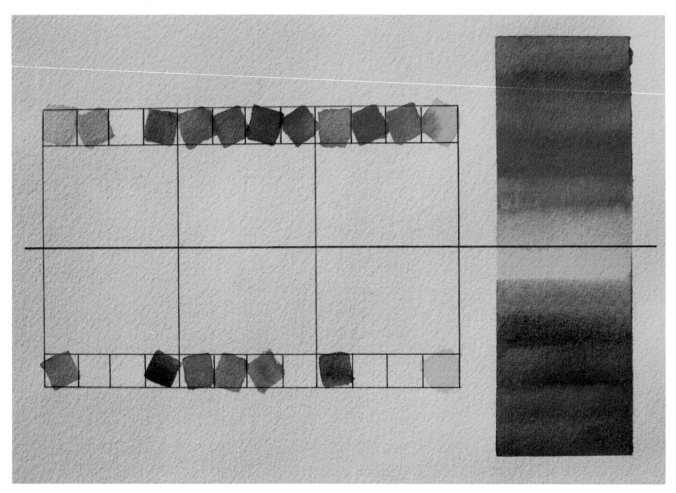

Figure 7-3.
Nature's spectrum and equivalent colors on palettes.

YELLOW OCHRE	BURNT UMBER	ALIZARIN CRIMSON
WINSOR BLUE	CERULEAN BLUE	WINSOR GREEN

Figure 7-4.
A basic color plan.

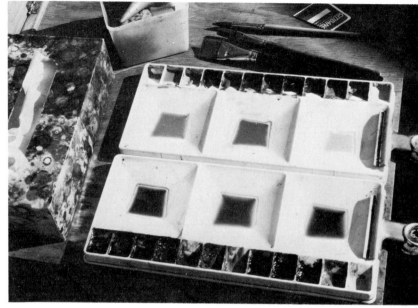

Figure 7-5.
Two Eldajon palettes.

Preparing Color

The diagram above (Figure 7-4) represents the mixing wells of two Eldajon palettes and a selection of a basic color plan.

After you select a color plan, prepare ample color by massaging the paint with a brush and plenty of water in the mixing wells of the palette. Premixed colors are vital when painting wet-into-wet, or when the need arises to strengthen or alter wet passages. As the painting progresses, colors in the mixing wells may lose their identity. If they do, you can clean them with a damp sponge or a tissue.

The diagram at right (Figure 7-6) shows how I arrange the colors on my palette. Those marked with an asterisk are on the palette at all times. Others are used only occasionally or are replaced with new colors from time to time, for experimental purposes.

If you're happy with a palette and a color arrangement other than that shown here, by all means stay with it. The main thing is to set your palette in an orderly manner, so that you get to know the location of each color without having to search constantly.

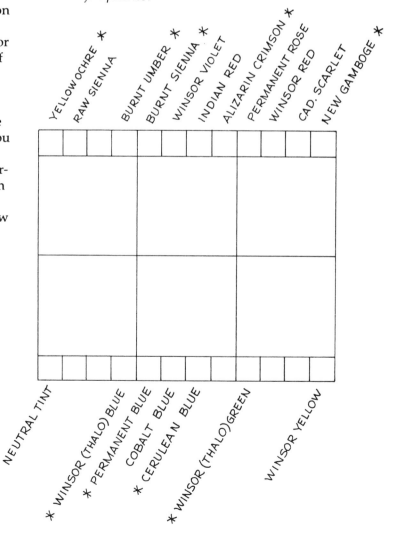

Figure 7-6.
Palette arrangement.

Mixing Luminous Grays

Any experience with the palette can lead to many surprises and discoveries. Our immediate concern, however, is how to use color to paint luminous and natural-looking pictures. Using complementary color is the key to transposing the effects of nature to the watercolor page. A color, when mixed with its complement, produces a luminous gray that can be quickly modified to go either way, warm or cool.

The chart below shows how lustrous grays can be made by mixing opposites. You can learn much about color by making a chart of your own like this. Lightly pencil in six bars, each about 1¼ inches wide by 8 inches long, on a quarter sheet of good watercolor paper. I use ¾-inch masking tape to divide and surround the bars.

Start with the left bar and brush in a graded wash of yellow ochre, full intensity at the top to a pale tint at the bottom. Give the paper a half-turn and, starting at the other end of the bar, immediately apply a graded wash of neutral tint, working from full intensity to a pale value. The cool color must be applied over the warm color while it is still wet, so the colors will mingle on the paper. Don't go into the wash once it has started to dry. Right or wrong, leave it alone or you will get a muddy mess. Now go on to the next bar and continue until all bars are completed. Neutral grays will result in the center area of each bar. When all washes are completely dry the masking tape can be removed.

Note that the color arrangement on the chart is similar to the arrangement of colors on the palette, with the warm colors above and the cool colors below. This arrangement makes it easy to locate colors to warm up a passage or to cool it down.

WARM COLORS

| YELLOW OCHRE | YELLOW OCHRE | BURNT UMBER | BURNT SIENNA | PERMANENT ROSE | YEL. OCHRE + CAD. SCARLET |

| NEUTRAL TINT | PERMANENT BLUE | WINSOR BLUE | PERMANENT BLUE | WINSOR GREEN | CERULEAN BLUE |

COOL COLORS

Figure 7-7.
Color chart (mixing grays).

Mixing Luminous Greens

Along with the grays, green is a useful color when properly controlled. It seldom should be used as it comes straight from the tube, except in a few selected areas where you want brilliant notes. No color requires as much diversity in hue and quality as green. Many watercolorists, when painting a summer landscape, find it difficult to avoid getting the whole picture too green. It is necessary to mingle mixtures of reds, burnt sienna, violet, and blue among the greens throughout the landscape.

You can make a variety of greens by mixing any of the blues with the yellows and siennas, and by mixing the greens with red, orange, or sienna. When mixed this way, your greens, like the grays, can be readily modified to go either way, warm or cool. It is the big areas of these grays and greens that provide a restful relief in a painting and keep it

from becoming too raw or overpowering.

The chart below shows how to make luminous greens from opposites. Here again, you can learn a great deal about color mixing by making your own chart, using the procedures outlined on the previous page. Luminous, neutralized greens will appear in the center of each bar.

WARM COLORS

| RAW SIENNA | BURNT SIENNA | WINSOR VIOLET | CAD. SCARLET | NEW GAMBOGE | WINSOR YELLOW |

| PERMANENT BLUE | WINSOR GREEN | WINSOR GREEN | WINSOR GREEN | WINSOR BLUE | CERULEAN BLUE |

COOL COLORS

Figure 7-8.
Color chart (mixing greens).

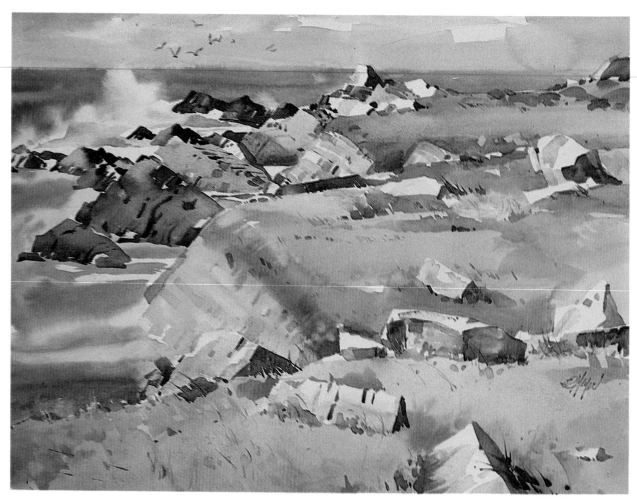

Figure 7-9.
Salt Point, 20x26 inches.

Painting with a Variety of Greens

A scintillating field of autumn headlands is captured in *Salt Point* (Figure 7-9) with a complementary play of lavenders and soft yellow-greens. I applied mixtures of cerulean blue and permanent rose directly to the dry paper, carefully cutting around the white rock outcroppings, and then quickly blended and softened these washes with a second brush and clean water. Light values of Winsor green and bits of Winsor yellow and new gamboge were brushed and dropped into the wet lavender wash. The fusing and neutralization of colors helped to express a serene mood.

Note how the picture space is punctuated with a zigzag movement from the foreground to the wave-splashed rocks, and then toward the blocky cloud shapes and white rocks to the right, followed by a downward play of interesting shapes. The distant fog bank echoes the colors of the land mass.

Ocean and surf were painted wet-into-wet with blues, greens, and bits of violet. The soft gradations of foam glisten against a variety of hard-edged rocks, simply stated with mixtures of Winsor blue, burnt umber, burnt sienna, and alizarin crimson.

The importance of introducing reds, siennas, and violets into a predominantly green subject is readily apparent in the watercolor *Bodega Mud Flats* (Figure 7-10). See how the value changes throughout the composition help to portray the glimmer of low tide. The mud flats are not a mud color but are rich with glowing complementaries. To achieve this ef-

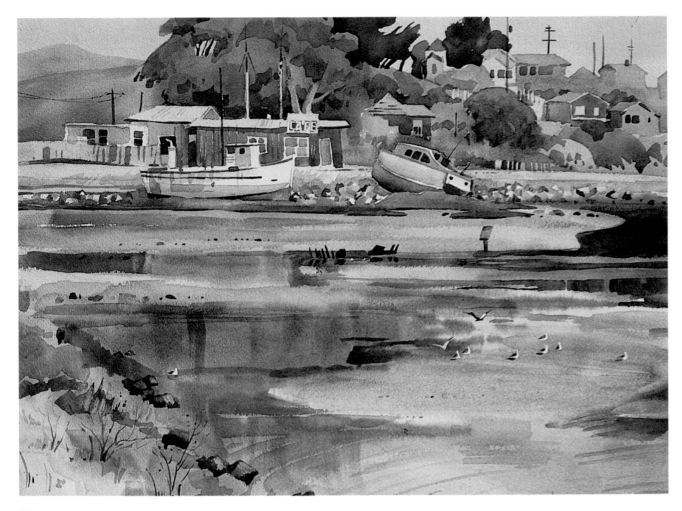

Figure 7-10.
Bodega Mud Flats, 18x24 inches.

fect, I put the colors down once and then let them
alone. Richer values were dropped in while washes
were wet. (Scrubbing into wet passages and over-
working them causes an opaqueness of color and
you immediately lose the light and the glow.)

The receding tidewater reveals wet sandbars, re-
flecting the brilliant light from the sky, which turns
their color to a light violet. The low water also re-
flects the colors of shoreline trees and man-made
objects. The moss and algae floating on the reced-
ing tide contain bright notes of yellow. A few bits
and pieces of orange and red along the shore com-
plement and enhance the greens.

Selecting a Color Scheme

A painting, to be colorful, doesn't need to have brilliant color throughout. In fact, just the opposite is often true. For example, a neutral background of luminous grays and browns will enhance and enrich small pieces of yellow and orange that are carefully placed within the composition. The final addition of luminescent darks will give a sense of light and depth.

In terms of value, yellow is the lightest, then orange, then red and green at middle value, followed by blue, and finally violet, which is the darkest. You can readily see that while yellow and violet are opposites in the color wheel, they are also opposites in value. Nature has also divided the spectrum into unequal areas, where yellow occupies about one-fifth, red one-fifth, and blue the remaining three-fifths. Using this as a guideline, if you do a watercolor with a low-keyed harmony of neutral tones you can make it sing with a splash of some brilliant color in a selected area.

Whenever two colors or values come together, they have an influence on each other's appearance. For example, if you want a grayed field to appear more greenish, paint a bright red object within it or next to it. Or a gray field can be made to take on a tinge of yellow when purple objects are introduced. Placing complementary colors next to each other will create the ultimate contrast, each intensifying the other.

The effect of this principle can be seen by placing a strong color next to a neutral gray. As an experiment, you can cut half-inch-square holes in the centers of small pieces of colored papers. When these papers are placed over a neutral gray background, the gray seen through the hole of the red paper will appear greenish—and so on.

I like to consider the possibilities of using yellows and oranges among a field of translucent green grays and violets. As I have indicated, I often build up my subject with patterns and shapes of values varying from light to dark. In the sketch of color patterns shown here (Figure 7-11), I've taken this procedure one step further and substituted colors for values. A variety of gray violets and gray greens were interspersed with bits of brilliant yellow and orange. A few darks were finally added for accents and interests. This color plan could be used with almost any subject. I found it particularly effective on the watercolor *Vallejo Dredge* (Figure 7-12).

Figure 7-11.
A selection of color patterns.

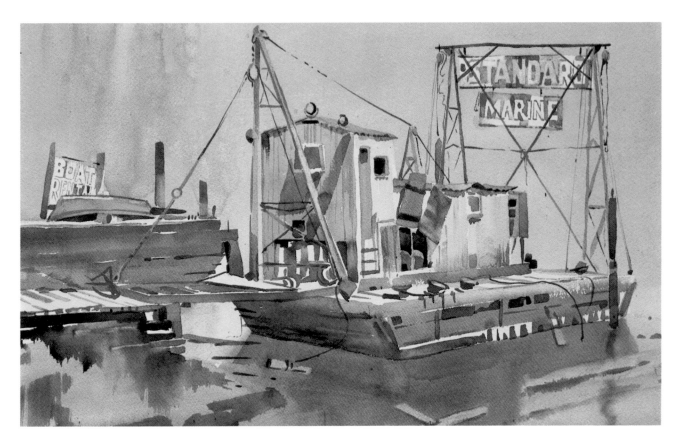

Figure 7-12.
Vallejo Dredge, 18x24 inches.

Painting Wet-into-Wet

The luminous colors in the painting in Figure 7-12 are layers of paint placed on the paper wet-into-wet. These act as underpaintings for the subject, which was then depicted partly by painting into the wet washes and partly by painting after the washes had dried. To keep light in the paint, I didn't mix the colors on the palette but allowed them to mingle on the paper with a minimum of brushing.

Washes and Glazes

Preliminary washes and glazes can be planned to give color unity to the watercolor painting. You can create strong color with underpaintings of well-planned intermixings of both warm and cool colors. These give a natural look without the garish effects of raw color direct from the tube.

Washes need not be limited to two colors, nor do you have to apply them with the board in a fixed position. By turning the board to any desired angle, washes can be kept under control. Many of my skies are made by turning the board upside down or sideways and then painting two or three colors over each other in varying intensities and directions.

For painting successful washes and glazes, the sheet should be prestretched so it won't buckle during the painting process. Keep the paper at a constant slant of about 15 degrees. By wetting the whole sheet with clean water before laying down washes, you can control color intensity and avoid hard edges. This also conditions the sheet and makes it more receptive to washes and brush strokes. Remember that pigments dry lighter on moistened paper, so more saturated color must be used than when you lay a wash on dry paper.

Controlled Glazes

The transparency of watercolor allows you to glaze or apply layers of paint over underlying washes that are completely dry without hiding them or covering them up. Instead, the underlying washes show through subsequent layers, creating a quality that is unobtainable with an opaque medium. Bear in mind, however, that the color underneath changes the hue of the paint placed on top.

To keep the glaze colorful, try to let one color dominate. Knowing that complementary colors neutralize one another, avoid using equal values of warm and cool colors. Often just a hint of a warm color under a cool one will result in a most luminescent glaze.

All colors, of course, should be well diluted when you lay washes and glazes. After the glaze has been applied, mop up any excess color outside of the picture area with a tissue or with a brush from which the water has been squeezed. Too often a nice glaze is ruined by runbacks caused by excess water at the edge of the paper while the glaze is drying. Keep the paper at a constant slant until the glaze has dried.

If you want texture, you can throw salt onto the glaze while it's still quite wet. Additional texture can be created by scraping into the glaze just as it starts to dry or just when the shine has left the surface. Timing is important in these techniques.

Effective glazes can be made by starting with stainlike colors (colors that sink into the paper and are difficult if not impossible to remove) and applying the heavy-bodied colors on top. An interesting effect can be obtained with progressive glazes of varying values, starting, for example, with Winsor blue (stain), then alizarin crimson (stain), and finishing with yellow ochre (body). Or you can do the reverse, starting with heavy-bodied colors and finishing with the stainlike colors, and you will also produce effective glazes. For example, you might start with yellow ochre (body), then manganese blue (body), and end with cadmium scarlet or alizarin crimson (stain).

If, as part of your technique, you plan to remove small areas of color from wash shapes after they have dried, you will find this is more easily accomplished in areas where body color has been used, or where staining colors have been painted over or mixed with body colors. A test sheet can be made by painting both separate and overlapping stripes on a good sheet of paper with the colors on your palette. When these have thoroughly dried, you can wet small areas with a brush and then gently wipe the wetted area with tissue. Some colors will lift right off while others (stains) will be quite difficult to remove.

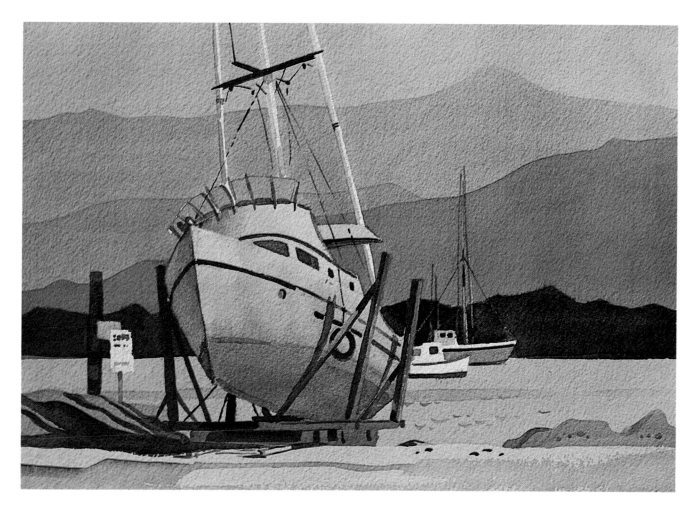

Figure 7-13.
Morning Sun, 12x16 inches.

Atmospheric Effects

In the painting *Morning Sun* (Figure 7-13), I glazed veils of cool blues over a warm light to capture the dazzling effect of sun on fog. Distant detail was eliminated to increase the effect.

First the boat and a few shapes around it were lightly drawn with a soft pencil. Then I applied a masking liquid to the side of the boat where the sun was hitting, as well as to a few areas where I wanted to save white paper. (Masking liquids are available from various manufacturers. They are used to protect areas of paper or previously painted areas from successive washes of color.) See *Painting Terminology,* page 157. After waiting a few minutes for the liquid to dry thoroughly, I moistened the paper by brushing the sheet with clear water from top to bottom. Then I painted a middle value mixture of alizarin crimson and new gamboge across the top of the sheet with a 1½-inch flat brush and allowed it to blend into the lower part of the paper.

When this had dried, I painted graded washes of permanent blue onto the paper with the desired values, starting with the lightest value, all the way to the horizon, allowing each wash to dry before applying the next. The dark hills at the horizon were painted with a mixture of Winsor blue and alizarin crimson. When the washes were completely dry the masking solution was removed and middle values of alizarin crimson and new gamboge were painted into this area. Dark details were added last.

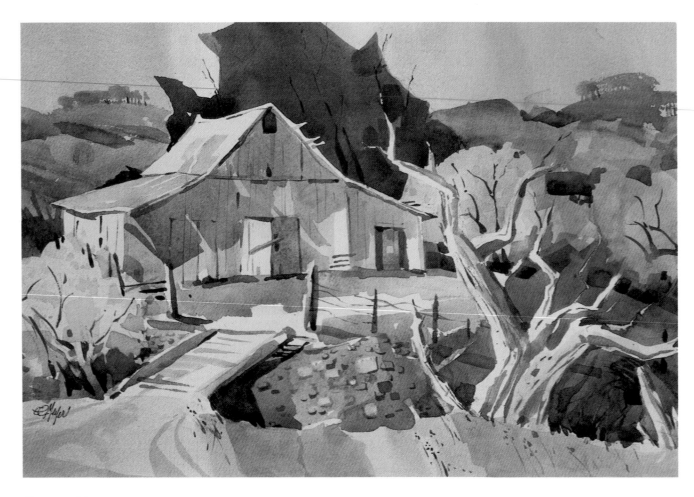

Figure 7-14.
Kenwood Landscape, 14x21 inches.

Limited Palette

Watercolor pictures can be quite bright even when you use but few colors. This is accomplished largely by selecting limited color schemes. In the paintng above, *Kenwood Landscape* (Figure 7-14), I restricted my palette to mixtures of yellows and violets with the addition of a few blues. No green paint was used. The muted greens you see were made by combining cobalt blue with the yellows. For the dark tree shape behind the barn I mixed Winsor blue with burnt sienna and a bit of new gamboge. The violet shadow across the front of the barn was made with a mixture of permanent rose and manganese blue.

Too many hues cancel each other and negate the feeling of color. Choose several warm colors and several cool ones. It helps to think of sunlight as being warm, and shade and shadows as cool. But the division of warm and cool should not be equal. Your painting should be either predominantly warm with a few cool spots or mostly cool with a few warm areas.

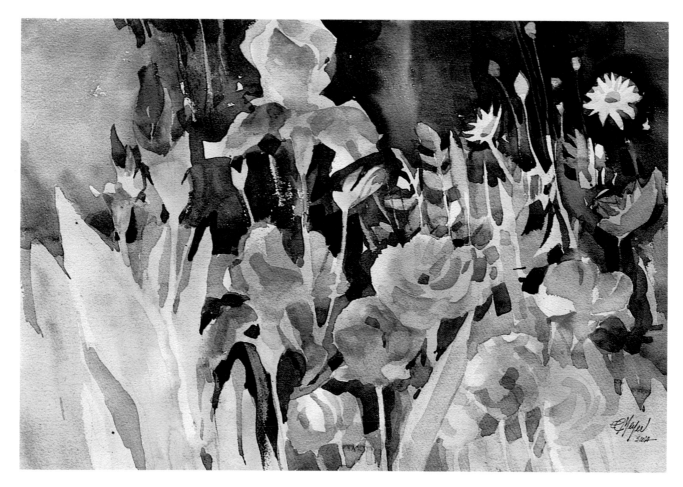

Figure 7-15.
Iris, 18x24 inches. Private collection.

Expanding the Palette

The more colors we use in a painting the harder it becomes to obtain a pleasing harmony. This is especially true when a number of complementary colors are used. To expand the palette, think in terms of selecting analogous colors (colors next to each other on the color wheel) rather than a number of complementaries. You can achieve a rich harmony with a selection of yellow-greens, greens, blue-greens, blues, and blue-violets, which you can play against a few orange-reds, as in the painting *Iris* (Figure 7-15).

When painting subjects loaded with color, such as these flowers, you can hold the vivid array in check by using powerful darks. These darks unify the design and isolate the colors, allowing each one to express itself fully.

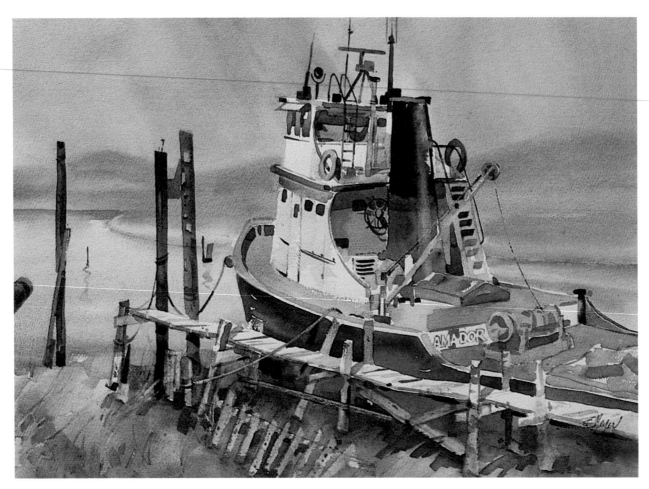

Figure 7-16.
Retired Tug, 18x24 inches. Private collection.

Getting Light into a Painting

An awareness of the way light hits your subject will allow you to design your composition with a judicious use of paper whites. While studying the original of this shoreline scene (Figure 7-16), I was struck by the brilliant whites of the tug which seemed to scintillate against the rich darks surrounding them, and I determined to capture the effect. Vitality is created by the vibration of warm and cool colors and the use of brave, dramatic darks to punch out the light areas.

The way you use paper whites can often determine whether the work will be a success or failure. Be careful not to remove too much of the light.

Once you've covered all of the whites, you can never get them back completely. Also, once washes have started to dry, scrubbing into them or adding wrong colors only muddies your picture. You fall farther and farther behind the more you work on it.

When this happens it is best to start over on a clean sheet of paper. Oh sure, you can grab the white paint and cover over those muddy colors, but you've lost the luminous glow. It is the translucent washes you can get with watercolor that make the medium so distinctive and appealing.

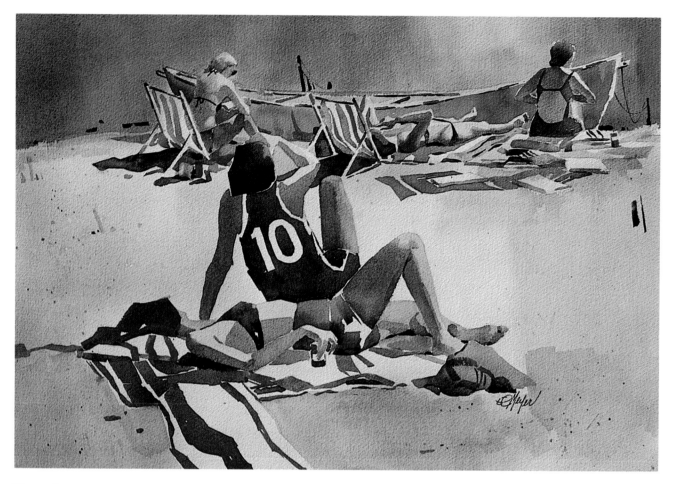

Figure 7-17.
Day at the Beach, 18x24 inches.

Summer Sunlight

The blazing sun on an August day often allows you to see only the darks and lights; the brilliant light seems to wash out all of the intermediate values. Yet within the strongly contrasting areas of color there is a shimmering play of closely related hues that you can use to advantage to increase the sense of light and warmth.

Exaggeration plays an important part here. Soft hues, which normally escape our attention in bright sunlight, can be isolated and brought into use to complement nearby passages. This helps to set up a vibration within the light values and the intermediate tones, making the subject more interesting.

In the painting shown here, *Day at the Beach* (Figure 7-17), the large interlocking diagonal patterns were first established with a 1½-inch flat brush and then glazes were overlaid to heighten the color and mood of a summer beach.

To increase the feeling of sunlight, I played warm yellows against cool violets. The jumble of bright clothing and beach towels was simply stated with spots of color, separated in places with bits and pieces of untouched white paper, which act as part of the design.

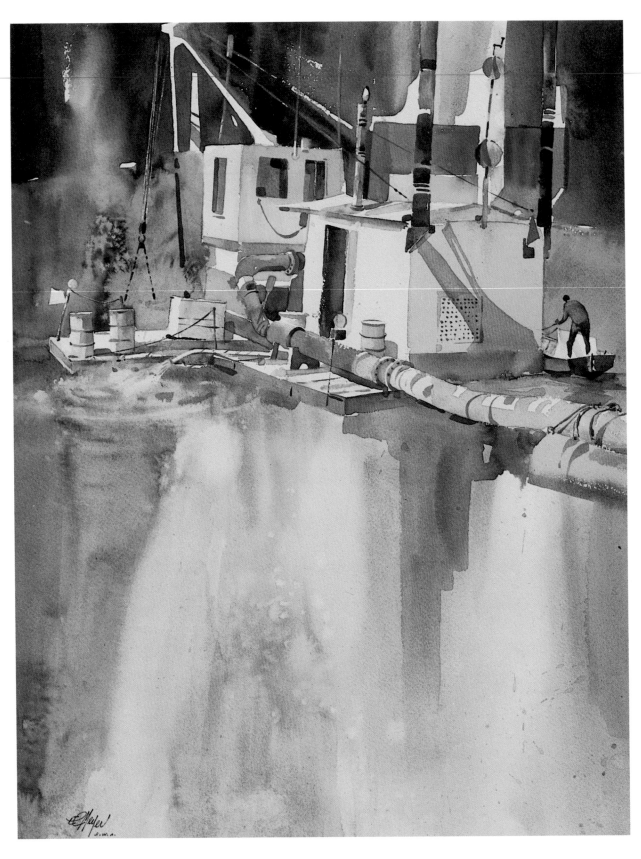

Figure 8-1.
Petaluma Dredge, 30x22 inches.

EIGHT

Painting the Changing Landscape

Light creates the mood of a landscape. Foggy days give everything a hazy, dreamy quality. All detail is eliminated and we see only blurred images and soft silhouettes. Bright sunlight, on the other hand, throws everything into sharp, crisp forms in which nothing is hidden.

The forms of clouds strongly lighted by the sun, and the undulating shadows cast upon the landscape below, can suggest countless moods through the exciting interaction of values.

The color you choose can also convey mood. Here again, light transforms colors and gives a glow to the whole painting. Evening light, for example, with the warm colors of a setting sun, will cast its charm on man-made objects as well as on the earth around us.

Technique is also responsible for the mood of a painting. With a wet-into-wet approach you can blur shapes; with controlled washes you can create hard edges that are useful for a crisp statement. All in all, watercolor is a wonderful medium for expressing the many moods of nature.

Enhancing Nature

When I first came upon the dredge on the Petaluma River I was immediately taken by the brilliant water reflections and the unusual display of color. In the watercolor (Figure 8-1) I enhanced the reflections by painting dark complementary colors across the top. These darks also accent the rugged overlapping shapes of the dredge.

Figure 8-2.
Photo of subject.

Figure 8-3.
Photo of clouds after a rain.

Skies

The sky is the source of light and sets the key and mood of a landscape painting. Sky color changes with the time of day and with atmospheric conditions. You will observe that normally a cloudless sky is quite neutral in color and makes a pleasing contrast in the more colorful passages of a landscape. Early in the day or toward sunset, however, sky color becomes warmer and more brilliant, especially when particles of dust, smog, or smoke are present.

You can make your skies luminous and natural-looking by painting a complementary color over a base color on a dampened sheet of paper. The colors are not mixed on the palette but are allowed to mingle on the paper. A wash of yellow ochre, for example, followed by a wash of ultramarine blue, makes a good neutral sky. Other colors can be brushed onto the sheet before washes start to dry. Skies normally get paler and greener about halfway down and then fade to a light lavender near the horizon. Skies, of course, are not always these colors. You can use almost any color as long as they are transparent and depict the atmosphere and time of day.

Clouds

Clouds are an ideal subject to make by allowing washes to mix and fuse, to suggest a wide range of atmospheric conditions. You can best depict fog, mist, and rain by applying your colors to premoistened paper and allowing them to blend into the wet surface.

When painting a sky with broken clouds, you can start directly on dry paper, applying paint with one brush and quickly blending the edges with another brush and clean water. Leaving areas of white paper will enable you to control the values before moving on to another area. A brush dipped in clean water and stroked from the lower edge of a cloud shape into the one you are about to paint below it will connect the two areas and create a natural-looking, misty atmosphere.

The day after a rain is a good time to observe cloud effects and to paint sky scenes. Study the clouds carefully and, when a pleasing pattern presents itself, fix the image in your mind. Freshness is essential; work quickly to get the big patterns. The undersides of the nearest clouds are warmer, with reds and siennas bouncing up from the earth below. Clouds get smaller and paler as they recede. Painting darker blue sky patches between clouds will cause them to appear more lustrous.

98

Water Reflections

For its color water often depends on what's beneath its surface as well as on the color of the sky. In clear water, a light sandy bottom will reflect more blue of the sky than will muddy water over dark rocks. Thick kelp beds near the shore often turn the color of the water to a deep green with violet patches.

Water movement breaks the surface into mirrors set at many angles, some reflecting light and others reflecting dark. Wind currents across a large body of water create large, irregular value patterns that help to structure a lively composition. When I painted the watercolor *Outside the Golden Gate* (Figure 8-5), prevailing westerly winds pushed the water into varied patterns that made a more interesting painting than would have been possible on a calm, overcast day.

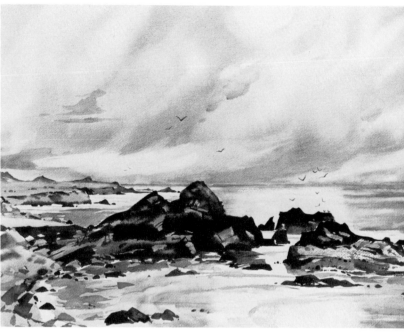

Figure 8-4.
Drifting Fog, 22x30 inches.

Figure 8-5.
Outside the Golden Gate, 22x30 inches.
Collection of Lynn & Gail Davidson.

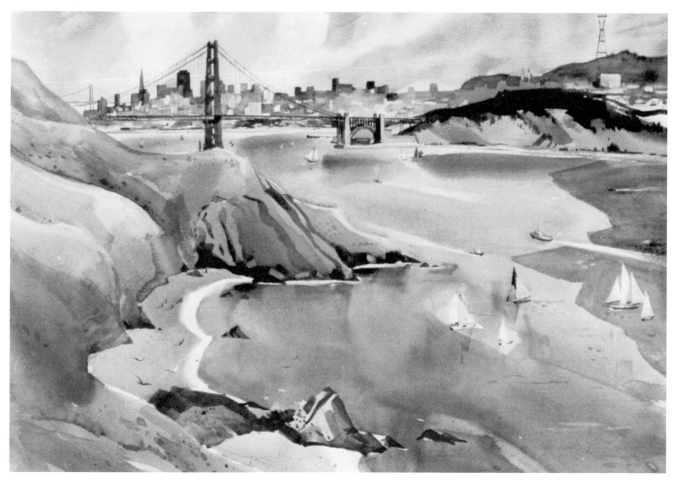

Figure 8-6.
Bodega Shore, 18x24 inches.

Foggy-Day Paintings

This picture (Figure 8-6) was painted on Bodega Bay, a place not far from my home, where there is the wealth of subject material typical of fishing villages. It is different each time I go there. The morning I painted this scene the fog was so thick I thought I'd have to go back inland in search of a more paintable subject. Finally, the fog lifted a bit, revealing big shapes without detail. All the things I didn't need were blocked out. In other words, it was perfect. The dreamlike, misty appearance made an ideal watercolor subject.

Watercolors painted on a foggy day, because of the moist paper surface, dry surprisingly lighter than you anticipated, and you need to use a more saturated color than you would normally. (The wet surface absorbs and dilutes the colors.)

I started this painting by covering the entire sheet with a wash of yellow ochre, grading my wash from dark to light from the left side of the sheet to the right. To accomplish this I gave the

board a quarter turn, which helped to control the flow of the wash. I then brushed a light, graded wash of cerulean blue, also from left to right, over the ochre wash while it was still wet. Next came a light wash of alizarin crimson, this time from right to left. I gradually introduced yellows and greens at the bottom and left side of the paper and mingled a bit of alizarin crimson into these areas.

When the sheet had partially dried, I painted the tree shapes with a middle value mix of Winsor green and alizarin crimson. Darker values of gray-greens were quickly added here and there. The building shapes were painted next, broadly and simply, with blue-violets, that I separated in places with raw sienna. Rich darks made with alizarin crimson, Winsor blue, and Indian red were finally used to strike in pilings, poles, and other bits of detail. Cool darks were placed against the warm light to gain the dazzling effect of sun on fog.

Figure 8-7.
Rock Outcroppings, 20x26 inches.

Cliffs and Rocks

Whatever the subject, boldness and abstract qualities are essential. They are especially valuable qualities when you paint close-up cliffs or rocks, which they can make into a powerful composition.

The watercolor *Rock Outcroppings* (Figure 8-7) was painted at Salt Point on the northern California coast. A gentle northerly breeze had pushed the fog out to sea shortly after my arrival. The whole area, with miles of rock outcroppings, shorelines, and forests, was now revealed in a warm autumn sunlight. Everything was paintable, but I was particularly interested in the effects of light bouncing in from the sky and the sea, which turned the rock forms into a good balance of powerful shapes with rich darks and brilliant whites. I painted the scene while facing the sun, as this allowed a simplicity of massing, particularly in the distant headlands.

When painting a scene such as this, you need to concentrate first on the big middle values and then punctuate these with large darks. Try not to record all the little detail inside the big masses. Most of this can be left to the imagination. If the shadow construction is good, the detail inside those masses can be assumed. Just a few calligraphic lines are needed to animate the large wash shapes.

Rock forms are best if you don't polish the surfaces too much. Textures that have a rugged vitality and that effectively depict rock formations can be achieved by scraping into dark wet pigments with a knife or with the edge of a credit card.

Coastal Scenes

One of the rewards of painting on location is the opportunity to build an exciting composition from the many lines and shapes that nature provides. In the coastline scene below (Figure 8-8), I was fortunate to find some large driftwood logs that provided good structural patterns. By placing warm sun-bleached logs against dark burnt logs, I was able to create a pleasing path for the eye. These bulky log shapes I surrounded and unified with a middle value sandy beach. The sand was painted with yellow ochre, warmed with burnt sienna and then neutralized somewhat with cool violets. Painting these colors into each other while they were wet contributed to a sunny glow.

You need to be able to visualize the scene on your watercolor paper before you start. Don't draw too much on the paper; you may change your mind during the painting process and wish to alter something you've carefully drawn in. More important still, your style becomes cramped as you follow lines you have previously drawn. Refer instead to nature and let your painting be more spontaneous. Try to let your brush do most of the drawing. When the big shapes have been brushed in, you can add detail, carefully considering its placement and direction. Pull attention to the center of interest with darks and rich color.

Figure 8-8.
Shoreline at Jenner, 22x30 inches.

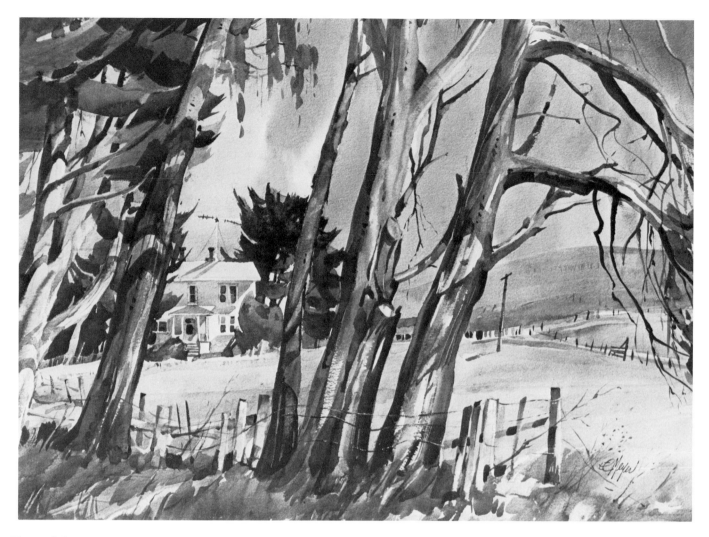

Figure 8-9.
Windbreak, 20x26 inches.

Trees

Trees are among the most useful objects in landscape painting because of their powerful design-making qualities. The entire structure of a composition can be based upon the spacing and interlacing of limbs and branches.

You need to study trees to make them work for you. Get to know them and their nature—how they grow and twist and sway, and set up related rhythms in their ballet-like movements.

The confusing detail of limbs and texture can be simplified by looking at them with light coming from behind. Then, through half-closed eyes, you can estimate the contrast of values as seen against the sky or fields that form the background. Look for the big shapes and patterns set in relation to one another.

The stance of a tree is important. Note the way the roots are spread out, the interlocking diagonals of limbs reaching out in all directions to tie together the big leaf masses. Shadows falling across limbs and trunks can be used to show form and direction. Tree shadows across the landscape make interesting patterns and accent the textures of rocks, grasses, and broken branches on the ground. These shadows add authenticity and excitement to the painting.

After you've washed in the large masses, you can indicate a minimum of leaf detail where light and dark meet. Also, a variety of small twigs can be added with the rigger brush. Put in your detail with an awareness of the total design or the picture can get spotty.

Tree Color

The predominant greens in spring and summer need to be subdued with warm notes carefully placed among them. The greens themselves should be painted with a variety of colors made by adding reds and siennas to the green mixtures. The color of trees depends on the season and the illumination, yet it is the variety of the warm and cool colors in both sunlight and shadow that gives your picture depth and volume.

Trees in autumn are alive with brilliant reds and golds, and a predominantly warm scene such as this needs to be subdued in places with cool colors or grayed with various values of complementary colors. It is the impact of warm against cool that brings a painting to life and makes it exciting. (In Chapter Seven, "Seeing Color," I explained how to mix a variety of luminous grays and greens useful in painting trees.)

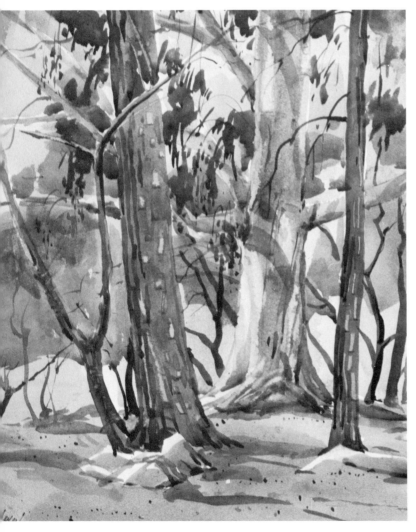

Figure 8-10.
Howarth Park, 11x14 inches.

Contrast

In this watercolor (Figure 8-10) I felt the way the light hit the large tree was important. A massing of distant foliage in simple silhouette patterns surrounds the big eucalyptus trunk, making the sunlight hitting the bark look even brighter.

To create bark texture I scraped my knife into the wet paint.

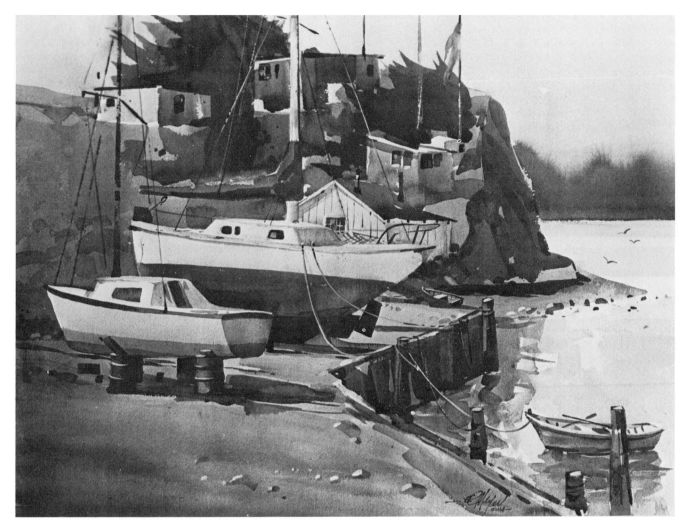

Figure 8-11.
Marshall Boatyard, **18x24 inches.** Private collection.

Boats and Boatyards

I enjoy painting in boatyards and can spend hours sorting out meaningful shapes for my compositions. I try to avoid a sentimental viewpoint and look instead for chunky shapes of varied color, texture, and pattern. Sometimes a shaft of light comes across my subject, enhancing the patterns of light and dark. When this happens I can see my picture already painted.

In the watercolor *Marshall Boatyard* (Figure 8-11) I tried for an explosion of light all through the painting. A fog bank covered most of the distant hills. Its brilliance was reflected in the water, which I left mostly white paper; this white area made a pleasing balance for the white boats. The foreground was painted with yellow ochre, which I neutralized with violet in a few places. The dark headland surrounding the light shapes was painted with violet

into which I brushed siennas, light greens, and dark blue-violet. I used only a few bright accents of local color—alizarin crimson and bits of orange—against a predominance of luminous grays. Finally, to indicate ropes and rigging, I added a few razor blade scratches.

When faced with a scene of complex confusion, with busy stuff everywhere, you need to simplify. There's always much more there than you really need. Start with an eye path that quickly gets you into the heart of the composition. Then search for a play of overlapping elements with alternating darks and lights to give vitality to the picture. Don't look for detail at this stage. After your big shapes have been freely brushed in, you'll be surprised how little detail you actually need.

Involvement

Searching for a paintable subject is, for me, part of the pleasure of painting on location. When I look for material to paint, my mind is full of compositional guidelines and I check to see if the subject meets these artistic standards. As I investigate the possibilities, I get emotionally involved and suddenly see where, by borrowing a shape from over there and by changing things around a bit, I can establish a good movement and display of patterns and values. This sketch was made with a Pentel sign pen as I searched for picture-making elements.

Figure 8-12.
Dot at Noyo Harbor.

Sunlight

The motif here is not important but it excited me because of the strong play of sunlight. Blues and violets dominate the scene, which is punctuated with complementary yellows on the cabin and in the foreground grass. The blue-violets of sky and boat spill down into the foreground, unifying the composition and setting up rhythmic warm-cool relationships.

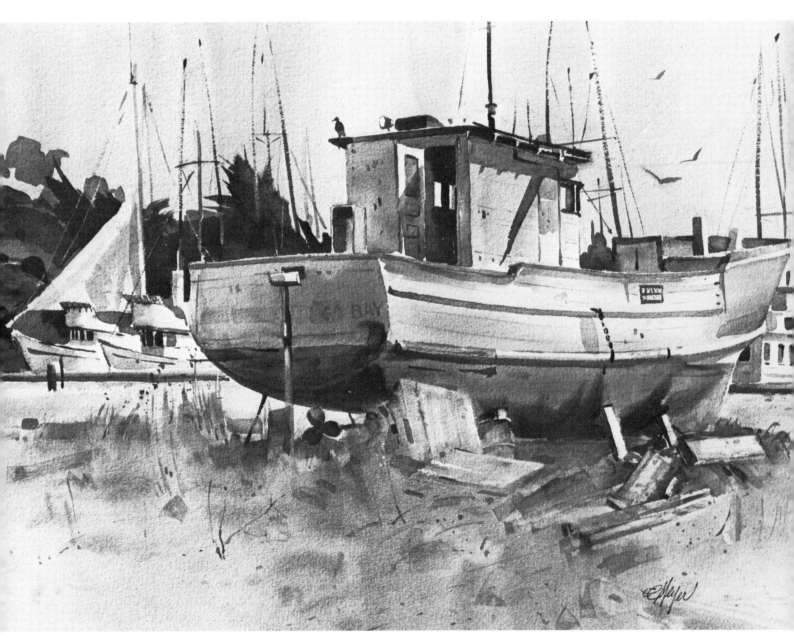

Figure 8-13.
Relic, 18x24 inches. Collection Bank of Sonoma County.

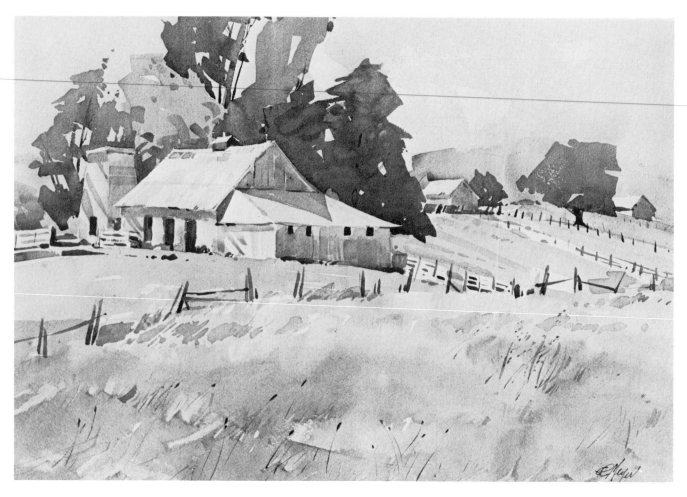

Figure 8-14.
Sebastopol Landscape, 18x24 inches.
Collection Mr. & Mrs. Dan Cherry.

Rural Scenes

Watercolor subjects are plentiful in and around the small villages of California's north coast. Along the back roads that connect these villages are numerous weather-beaten buildings of another era. The variety of shapes and textures is always most tempting.

There are, however, very few ready-made subjects. As I've pointed out, elements of the scene need to be selected and moved around if you are to come up with a simpler, more workable plan. In the painting above (Figure 8-14) the barn was deliberately moved off-center to allow for a more interesting lead-in than actually existed. Values were also reorganized to help structure the composition.

Painting almost entirely with a 1½-inch flat brush, I quickly washed in complementary colors, leaving the building shapes as white paper. Cool blues and violets were used in the sky to contrast with the warm yellow-orange fields. I neutralized the immediate foreground by brushing the mixture of burnt sienna and Winsor violet into the underlying wash while it was still quite wet. A few brush handle scrapings were used to indicate texture in this area just as the washes started to dry. (When the surface shine has left the paper is the right time to scrape into paint for the most effective results.)

To indicate a warm, reflected light bouncing into the shadow areas of the buildings, I painted yellow ochre and a light alizarin crimson into a cerulean blue wash.

The dark tree shapes I painted last, also with the large brush, with gray-greens made with alizarin crimson and Winsor green. These darks punch out the building shapes and put some snap into the picture. I like to extend the value range and use contrasting, glowing darks next to paper whites.

Figure 8-15.
View to the sea.

Close-ups

This sketch illustrates how only a portion of a structure or a scene needs to be shown in order to develop a pleasing design, one that is not overloaded with confusing, unrelated material. Sometimes it's better to select a few interesting features and concentrate on these rather than to struggle with a complicated panorama that says nothing.

Figure 8-16.
California gingerbread.

Ornate Buildings

Victorian mansions have always been a favorite subject for artists. You can find these ghosts of another era rising up and punctuating the urban skyline of nearly every town or city. Most of these structures have been well maintained or restored, while others seem to cry out for someone to care for them. All are impressive, with their exuberant display of finials, balusters, parapets, and gingerbread that go all the way past Victorian to rococo, beckoning the watercolorist to enrich colorful washes with exciting calligraphy.

In the sketch shown here (Figure 8-16) I wanted to play up the clash of cultures, with mobile homes and the old Victorian mansion juxtaposed in the coastal landscape of southern California. The old mansion stands as a remnant of the area's rural history and the mobile homes are metal monuments to one of the spurts in continuing urban growth.

Ornate buildings are not confined to Victorian times but include a variety of structures, many with great historic significance. Among these are the Spanish missions, which extend all the way from Old Mexico, through southern Arizona, and into most of California.

Mission Dolores (Figure 8-17) was founded in 1776 by Father Palou on an expedition from Tubac, Arizona. During the 1960s I had a studio in Tubac and often painted nearby Tumacacori as well as Mission

110

San Xavier in Tucson. Prior to this time I had traveled the length of El Camino Real and painted all twenty-one California missions.

This watercolor expresses some of the design- and pattern-making possibilities of these historic structures. Weathered adobe walls, capped by orange tile roofs, are quite striking among the muted greens, ochres, siennas, and violets of the surrounding landscape. Ornamental gates, doors, windows, and balconies provide decorative accents.

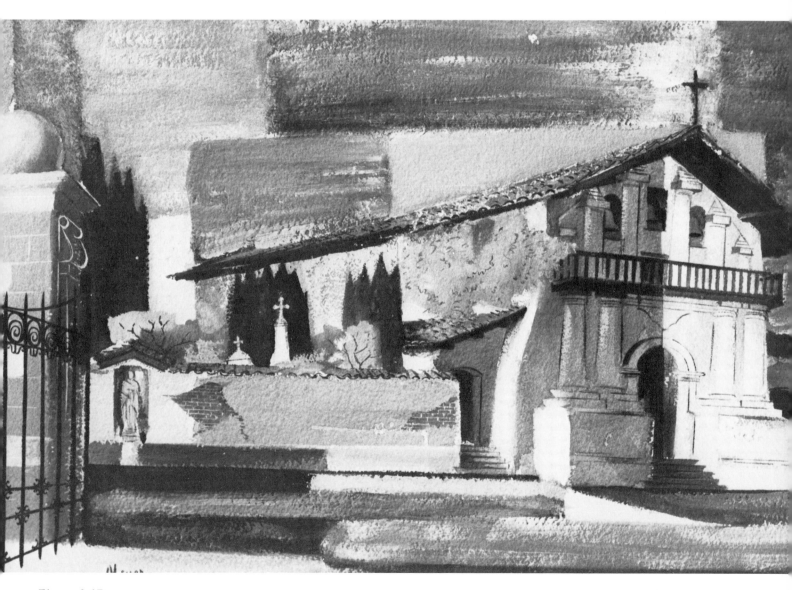

Figure 8-17.
Mission Dolores, 14x21 inches. Collection of the artist.

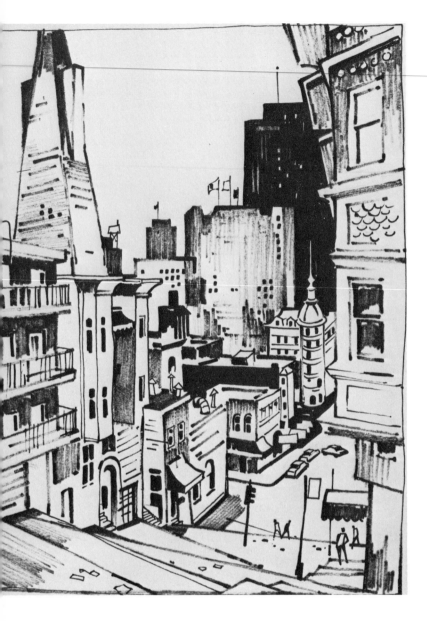

Figure 8-18.
Montgomery Street.

Painting in Towns and Cities

Towns and cities throughout the world have supplied the artist with rich, colorful material for centuries. Churches, temples, railway stations, schools, factories, skylines, and street scenes continue to offer today's painters an exciting display of color, texture, and pattern. Some artists are more interested in faithful renderings to show what a building looks like, while others are drawn to the artistic arrangement of shapes and values. Still others concern themselves only with the effects of sunlight and cast shadows.

Using buildings as subject matter is especially rewarding, since it allows a division of the picture space into many-sized rectangles. If the light is right, a dark-light pattern can easily be established and unity achieved with connecting shadows.

A concentration of buildings, windows, rooftops, and signs is composed almost entirely of rectangles, and you require a contrast of breathing space to make it an effective picture. Restful areas, such as a park or a long view with an uncluttered foreground, help to create a variation in the sizes of shapes.

A variation in values is equally necessary. A white wall in sunlight is white only because of darker values next to it or around it. The composition gets more complex when you bring in a wide range of tones and you must see to it that they are balanced skillfully. Usually, a small area of contrasting tones can echo one or two larger areas to help convey a feeling of dimension and space. Making several small compositional roughs will help you determine a good distribution of both values and shapes before starting the full-scale watercolor.

Painting on location in cities can become difficult, particularly if you want to do a view of a downtown street. Better to come back on a Saturday or Sunday morning, when the Monday-to-Friday crowd has left for the weekend. Finding a suitable place to set up your easel usually calls for advance scouting. It's most desirable to paint from a vantage point in a park or playground, or on a hill where there is little or no traffic. This also provides the long view that I mentioned previously. The view of *Montgomery Street* (Figure 8-18) was sketched from the top of a hill too steep for through traffic.

Sometimes it's a good idea to make a number of

quick sketches from which a studio painting can be made later on. Or a watercolor can be started at the site and completed in the studio. The advantage of this is that you're less likely to overwork your subject and can better judge where the final accents need to be placed. Many artists paint city views and street scenes from photographs, but working from sketches is much preferred, since the result is more inventive and spontaneous. Although the camera is often the only means of capturing a lively street scene, you must take care, when working from photographs, to avoid a stilted or excessively overworked watercolor.

Figure 8-19.
A Sonoma street corner sketched with a felt-tip pen.

Interplay of Darks and Lights

In View of the Bay (**Figure 8-20**) the arresting patterns of alternating darks and lights express the design possibilities of a concentration of building shapes. Largely I ignored vanishing points, which helped me to structure a somewhat two-dimensional, mosaic-like composition.

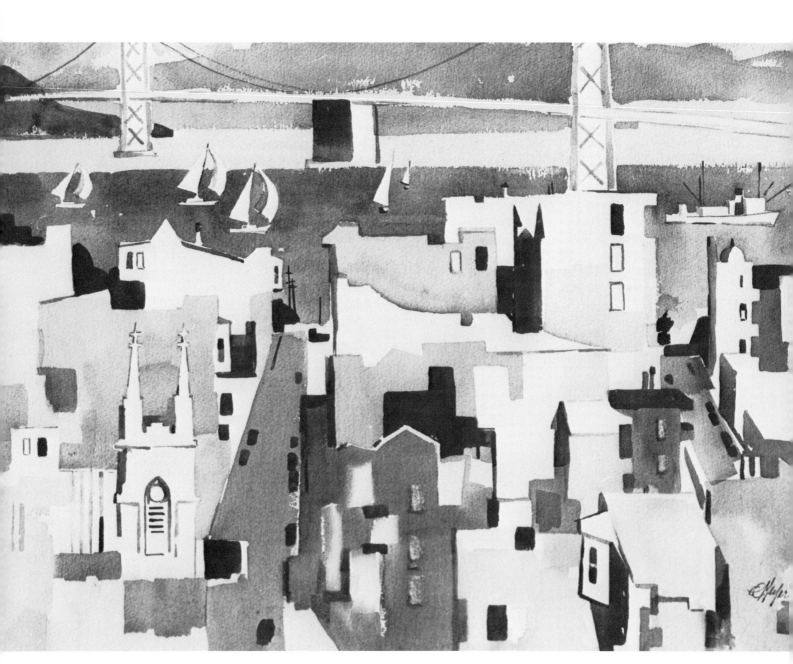

Figure 8-20.
View of the Bay, 18x24 inches.

San Francisco, with its many hills and unique architectural variety, provides interesting subjects that are fun to paint, especially if you can find a vantage point away from the profusion of pedestrians and traffic. I know the area well, having lived there for thirty-five years, and have found that good painting spots are best reached on foot. When I paint here I take only a minimum of equipment: my sketchbook, a plywood board with clips to hold my papers, and a tackle box to carry brushes, palette, and colors. Water is in an army canteen on my belt. I don't take my easel, but merely prop my board on my supply box or on some handy object.

View of the Bay, (Figure 8-20), was painted with my board resting on a retaining wall near the top of Russian Hill, where a spectacular view of the northeastern waterfront had beckoned me to get out my paints.

As I said earlier, I often make a few small compositional sketches before I start my picture. I felt a definite need here to eliminate detail and to see only the large shapes of this busy scene. To do this I found it helped to squint, so that detail became somewhat blurred and indistinct.

After penciling in key shapes of the scene, I started to paint directly on the dry sheet. Mixtures of violet, made with Winsor blue and alizarin crimson, were put down with my 1-inch flat synthetic brush, cutting carefully around some of the white shapes and letting pigments run together in other areas. A few of the shapes were painted with yellow ochre to complement the blue-violet areas. I used Indian red in several of the darks. Paints in a few areas were scraped with a cut-up credit card just as the washes were starting to set up. I worked on a section at a time so that I had control. Most of the dark shapes were added at the last.

As I started painting the scene, a regatta was taking place on the bay. I left areas of paper whites untouched for the boats, simply painting around their shapes. The regatta helps to animate the scene and makes for a happy mood.

Painting at the Edge of Town

You can find exciting material on the outskirts of most cities and towns. Often there is a vantage point in a public park that will allow you a good view of the area.

Fort Baker Rooftops (Figure 8-21) was painted from a small hill just north of the bay, near the Golden Gate Bridge. The bridge itself was obscured by drifting fog, allowing me to concentrate on the sun-lit buildings of this old retired army post. The many tree shapes that form the backdrop behind the buildings are combined into one large dark shape, which pushes the subject back into space. The area behind the trees reads as sky but is actually a bluff.

When dealing with buildings that angle in many directions, as these do, it's good to have some knowledge of perspective. Methods of dealing with perspective are discussed in Chapter Six.

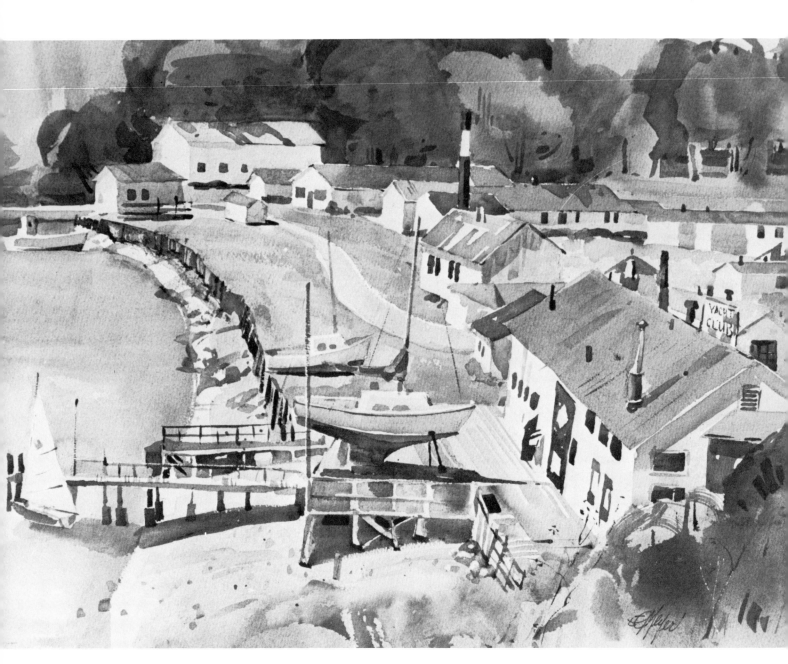

Figure 8-21.
Fort Baker Rooftops, 18x21 inches.

The Helpful Onlooker

When you set up your easel in a public place you're bound to have a few casual onlookers. They never stay long, but even so some artists don't like to have anyone watching. Onlookers soon go away if you ignore them. Sometimes I enjoy talking to people who come over to see what I'm doing and I have learned a great deal about the history of the place or about other interesting painting locations in the vicinity.

Some onlookers would like to get right in there and help you with the picture. Once, while I was painting in San Francisco's Chinatown, several Chinese ladies watched me struggle with the Chinese characters on some signs and offered to brush them in for me.

Another time, while painting a weather-beaten roadhouse, I was completely absorbed in the artistic merits of faded boards, old signs, patched windows, and leaning roofs—all wrapped up and embellished with a jungle of antenna wires and power lines. An onlooker who had been watching my hopeless attempt to capture the scene finally tapped me on the shoulder and exclaimed, "Mister, if you'd like a bit of advice, move in real close and use a big, big brush."

I've found people to be very considerate of the artist who is out working on location. One day, while I was painting a group of interesting boats tied up at a wharf, the owner of the cabin cruiser which was the center of my composition came over to ask if it would be all right if he continued working on his boat while I painted the scene.

People usually just say hello as they walk by. Sometimes they ask questions, like the fisherman who asked if he could fish on the rocks straight ahead or would it spoil my view? A question that I occasionally hear is, "Are you an artist?" Sometimes I get a compliment. Once an onlooker remarked that my painting looked better than the real thing. Since I had only painted in the bold background washes of a dilapidated wharf scene, it made me stop and think—How much detail do I really need?

Most of the time I can paint for hours without anyone stopping by, or perhaps I am so involved in my painting that I don't notice. Much of my painting is done on private property or in locations where there are few people around. When you're painting in an area where there are bound to be interested bystanders, it helps to be with painting companions. People then decide that this must be a painting class and are less likely to interrupt your concentration.

NINE

Introducing the Figure

There are times when your painting will benefit if you include people in it, particularly when the subject is one where you'd expect to see people, such as a street scene, a summer beach, or a ski resort. Including figures will add scale to the scene and put life into your landscape. It can also be a means of focusing attention on certain areas.

The figure can be used in a painting in two ways: in one the figure serves primarily to add interest or scale; in the other the figure is the main subject. To be able to put figures into your landscape primarily to add interest doesn't require a long training in life drawing. The important thing is that the figure show some action and movement; if you make them simple yet in keeping with their surroundings, you will find that much can be implied through gesture alone and that a minimum of drawing of detail is needed.

A figure in a composition commands attention, so it's essential to locate it with great care in order to keep the composition in balance. It must be introduced in the initial planning of the picture and then painted with the same freedom and technique as the rest of the painting. To wait until the end, or to introduce the figure as an afterthought, often causes it to appear contrived and out of place. Adding figures that don't fit in with the design and style of the composition can easily ruin what otherwise might have been a good painting. It's important that figures be introduced with an eye toward the total effect.

Shown here (Figure 9-1) is a sunny beachscape, carefully composed to direct attention to a colorful grouping of figures in related activities. A designed contrast of both values and colors gives visual punch. The watercolor was started on location and completed in the studio.

118

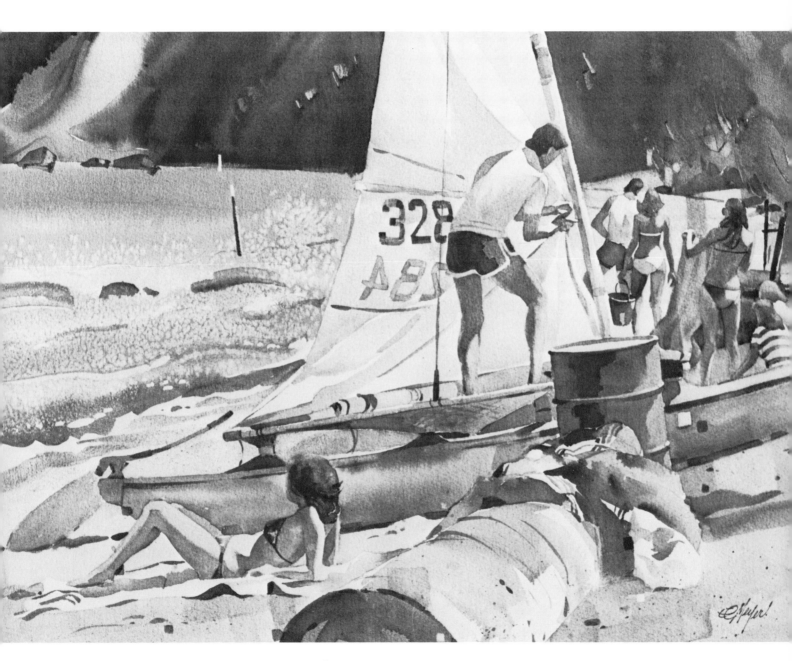

Figure 9-1. Afternoon at China Camp. 18x24 inches.

Sketching the Figure Outdoors

Figures in outdoor situations will usually prove to be very valuable in your watercolors. The figures should show character and movement and should be done as simply as possible. In sketching, I find felt-tip pens in a variety of points, from thin line to broad strokes, are the most useful, but charcoal, pencil, and other tools are good too. It is also helpful to sketch figures with a brush, so that they can be formed just like the other elements of your composition. They will then fit in naturally with their surroundings.

When sketching figures, try to group several people into one unit and tie them together with dark passages. Let the middle tones become either part of the light shapes or part of the darks. Sunlight helps here as it throws everything into passages of light and shadow. I don't put in facial features; it's best to treat the figure as a silhouette, a dark shape against the light or a light shape against a dark background. This alone is sufficient to make the subject recognizable, and will help you to see the action and the overall contour.

Continuously drawing and sketching figures is essential in making them appear convincing and natural. Subjects for quick sketch impressions are all around. People on the sidewalk can be sketched from the comfort of your parked car. You can also find all sorts of color and activity in parks, playgrounds, yacht harbors, beaches, and shopping centers. There seldom is time to record every little change in the planes of the body or to show a great amount of detail. This is good because it forces you to think only in terms of the large areas of shadow and light, and to see how these come together. Pay attention to the kinds of clothing people wear in different surroundings or activities. Appropriate dress will lend authenticity to your picture and often can provide a needed spot of color.

The Indoor Model

Sketching and painting from the live model will help you sharpen your ability to draw the human form. Perhaps even more importantly, it will provide you with an opportunity to discover a rich source of dynamics that can add much to your compositions. The human figure, with its immense variety of tone, color, and movement, can invigorate your work. The structure of the figure, viewed from different angles under various lighting conditions, and the dynamic thrusts of the body in various positions, are but a few of the abstract elements you observe and draw.

Most cities offer classes in figure drawing, where you can sketch or paint from the live model. If

Figure 9-2.

none exist in your area you can use family members or you can form your own sketch group, as many artists are doing. It's important to find good models with intelligence and imagination, as their poses will prove to be the most inspiring. Accessories such as studio props, clothing, costumes, beach chairs, and similar items can add to the color and interest of the pose.

Figures are always a challenge and can contribute much to a painting. You can use a great variety of techniques to draw them.

Figure 9-3. Sausalito sketchbook.

121

Figure 9-4. Arizona sketchbook.

Sketching the Indoor Model

It takes practice to learn how to draw tension in the human figure but it's well worth the effort. Tension is created when parts of the form are stretched while other parts remain relaxed. Such poses can only be held for short periods, often just a few minutes, so you need to sketch rapidly, concentrating on the action. If your pencil or charcoal lines are wrong don't waste time erasing and redrawing. Drawing correct lines alongside those that have gone wrong and reinforcing the correct ones will result in a progressive statement that helps to express action (Figure 9-6).

Less strained poses, in which the model is reclining, can also express a sense of movement by the way the body is twisted and by the jutting forms of pelvis, arms, and legs breaking up the picture space (Figure 9-7).

You can integrate the background and the figure by allowing some of the background values to become part of the figure's tonal patterns. An awareness of edges is essential in order to link the figure with the background. A good balance of shapes and color, with lost and found edges, helps create a feeling of mystery where the figure is emerging—almost (Figure 9-8).

A light source from above or from the side produces strong dark-light patterns that allow the figure to alternate between positive and negative shapes, thereby setting up a rhythmic flow of light and shade, as shown here (Figure 9-9). This enables you to express the weight and volume of the model convincingly.

A type of figure drawing many artists find useful is the contour drawing, where lines describe the middle of the form (the edges of tonal areas) as well as the outline of the body. Here again, a

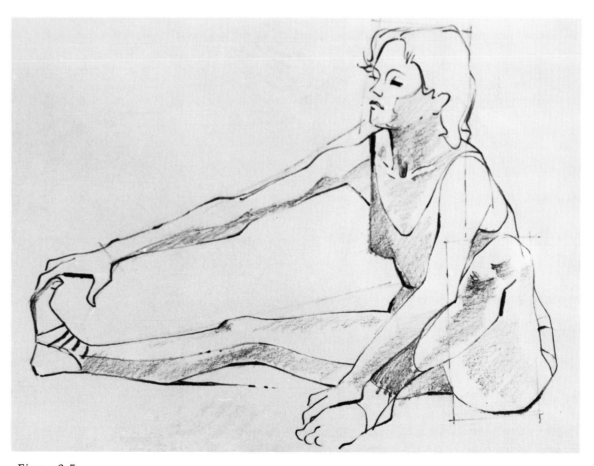

Figure 9-5.

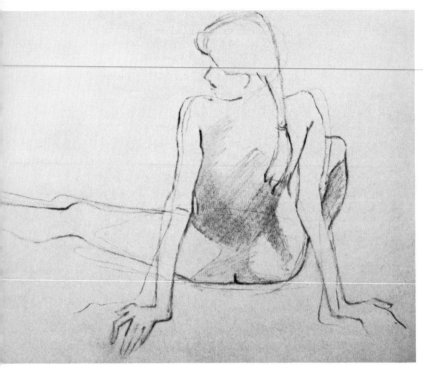

strong overhead or side light will allow you to dis-
cover shapes that are near-abstracts and can help
give vitality to a figure drawing.

Allowing parts of a figure to overlap one already
drawn is a rewarding way of creating new shapes
and forms. Be selective when you add more fig-
ures. Carefully placed tone can contribute to the
pattern and design (Figure 9-11).

Figure 9-6.

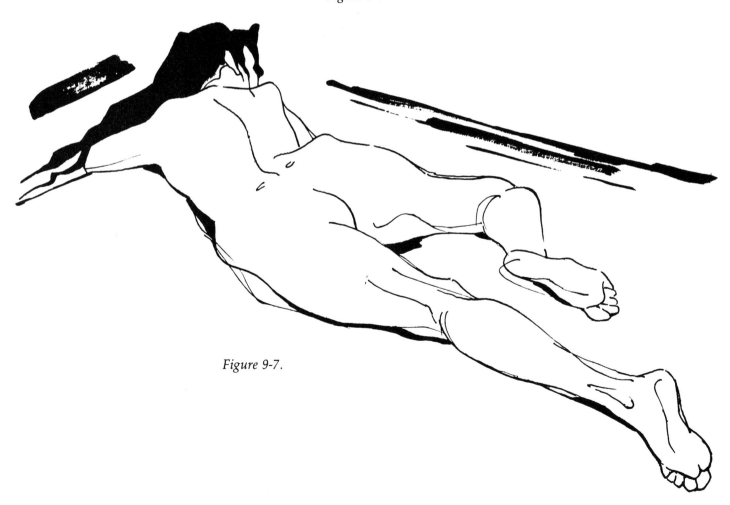

Figure 9-7.

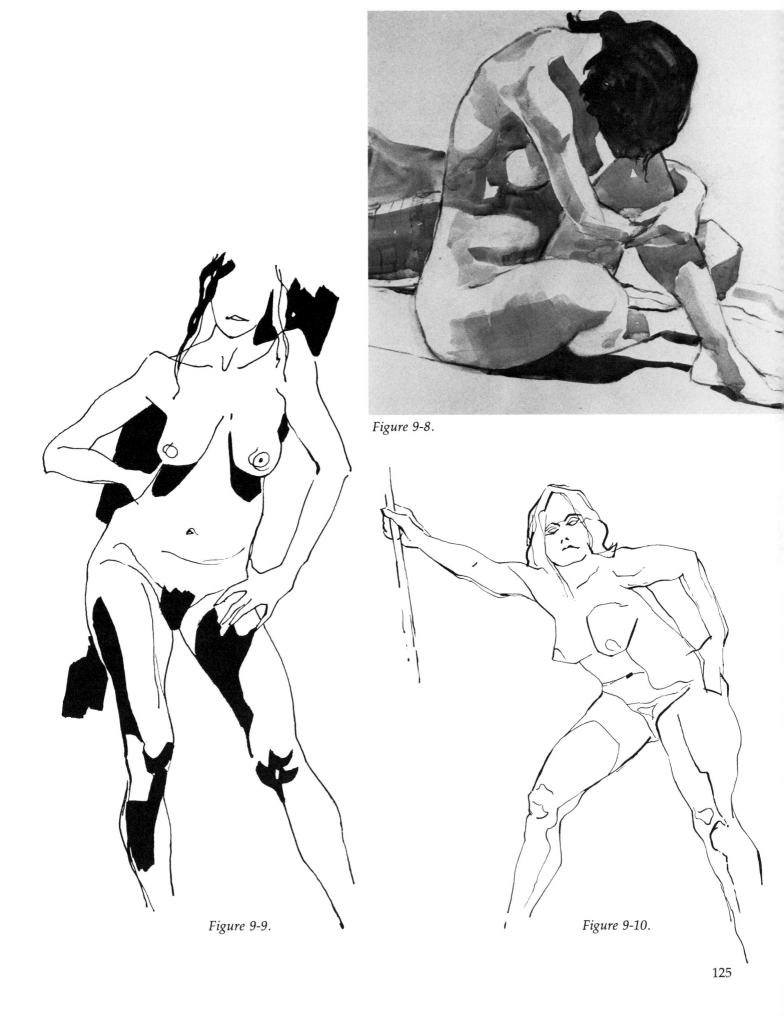

Figure 9-8.

Figure 9-9.

Figure 9-10.

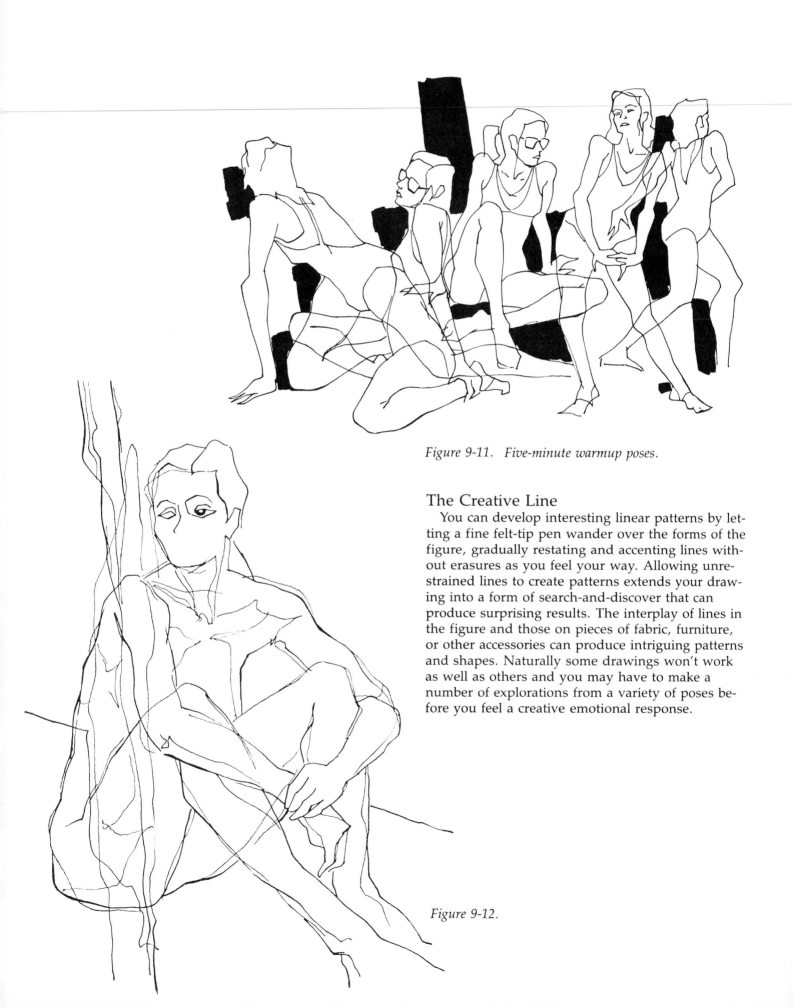

Figure 9-11. Five-minute warmup poses.

The Creative Line

You can develop interesting linear patterns by letting a fine felt-tip pen wander over the forms of the figure, gradually restating and accenting lines without erasures as you feel your way. Allowing unrestrained lines to create patterns extends your drawing into a form of search-and-discover that can produce surprising results. The interplay of lines in the figure and those on pieces of fabric, furniture, or other accessories can produce intriguing patterns and shapes. Naturally some drawings won't work as well as others and you may have to make a number of explorations from a variety of poses before you feel a creative emotional response.

Figure 9-12.

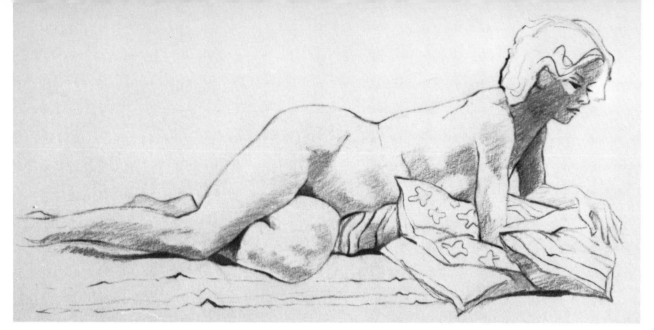

Figure 9-13. Charcoal drawing.

Figure-Painting Procedures

When the figure is used as the main subject of a composition, the watercolor can be painted directly from the model or from a drawing or sketch you've selected from a number drawn from the live model. Working from such a drawing allows for a more controlled handling of the delicate variations of tone and color. The charcoal drawing shown here (Figure 9-13) is a relaxed pose with good lighting and is typical of one from which a watercolor could be painted.

When you pose a model, always pay careful attention to the direction the light is coming from. As Figure 9-14 demonstrates, the way the light hits the figure is important in achieving distinctive shadow shapes. The forms of the model's figure and the shadow patterns need to be linked and painted with lost and found edges in order to get an overall flow of light throughout the composition. Backgrounds should be kept simple and unobtrusive so the figure has more importance. Dark accents play up the luminosity of color in lighter areas.

The watercolor shown in Figure 9-14 was painted directly from the model. First the main shapes of the figure were quickly positioned on the watercolor paper (Arches cold-press) with a stick of soft vine charcoal. Next, unwanted charcoal lines were erased. The figure was then painted in controlled areas, starting with the head. I used two brushes, a No. 12 pointed synthetic round to apply paint, and a moistened 1-inch flat synthetic brush to blend color and soften edges. Skin tones were painted in different values of violet, burnt sienna, and cerulean blue, with occasional hints of pale, grayed yellow-greens. A variety of purples were used in the jacket and in the background to complement the yellow ochre and burnt sienna colors of the model's hair.

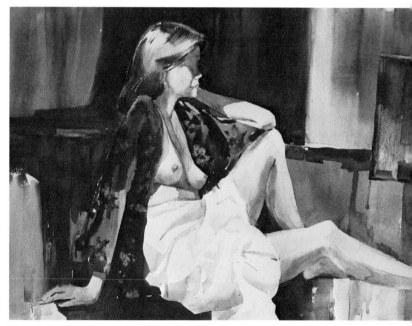

Figure 9-14. Seated Model, 18x24 inches.

TEN

On-Location Demonstrations

So far I've discussed the many elements that go into watercolor painting and provided examples and descriptive accounts of my painting methods. In this chapter I'll show, in step-by-step demonstrations, my actual on-location painting procedures from the rough sketch to the finished painting. The demonstrations are of subjects near my home in California. Photographs of the subject are included as a point of reference to show that the design elements necessary for a good composition are not always readily apparent, but need to be searched out and developed in preliminary sketches or as you paint.

Demonstrations are excellent teaching devices, but I must admit they aren't the easiest way to paint satisfactory pictures. I try to finish my paintings in a reasonable time, before the light changes everything. I seldom work from photographs as I have discovered that watercolors painted on location are more alive and more spontaneous; on-location paintings have an authenticity that I like.

My thinking and feeling as I work are hard to describe. I try to sum up all the preparatory devices I've shown in previous pages. As I start to put down washes I become intensely absorbed in trying to get light into my picture. I become increasingly aware of the way light hits my subject and the effect it has on colors and values.

All of the demonstrations are painted on prestretched Arches rough 140-pound watercolor paper.

The Changing Scene

A dilapidated wharf overlooks a variety of water-soaked structures glistening in the morning sun. Tides and floodwaters constantly shift things around, rearranging a patchwork of shapes, values, and color. Everything is different each time I return. But that is part of the challenge and excitement of painting on location.

Figure 10-1. On location near Vallejo. The completed painting is shown in Figure 7-12.

Demonstration 1

Village Scenes

The scattered and confusing elements of a village landscape often fall into place when you move your easel fairly close to the scene. This will show your subject more intimately and allow you to break up space with interesting patterns. The light on the subject, however, isn't always at its best. Jumping right in and capturing the scene as it exists at the moment may not offer the best possibilities. As the light constantly changes, it often reveals shapes, dimensions, and thrusts of forms that can help structure a more powerful composition. I often return to familiar subjects and each time the light is different.

Having painted this north coast village from different angles and at different times of the year, I chose to paint this demonstration in May, after the fog had drifted out to sea and the town lay basking in a flood of sunlight. The photograph shown here was taken about midmorning from the spot where I had set up my easel.

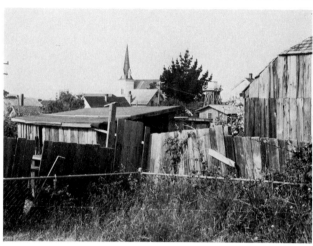

Figure 10-2.

Step 1. As I search the scene for a starting place, my eye is stopped by the contrast of leaning, sunlit fence boards against the dark openings of the near-by shed. Continuing to look at the scene, I see a number of dark-light repeats where dark rooftops meet sunlit walls. I design my composition with these alternating contrasts.

Sketching with a felt-tip pen is a quick way to pretest the balancing of middle values and darks. I try not to dwell too long on one area, but keep my pen moving all over the sketch to establish a movement or flow of light. The display of buildings and backyard fences has an abstract quality that helps to structure a forceful design.

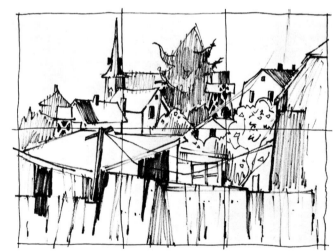

Figure 10-3.

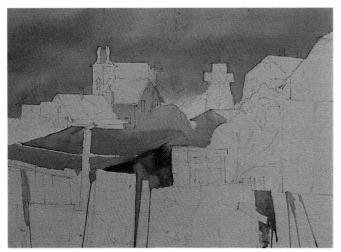

Figure 10-4.

Step 2. With my sketch as a guide, I pencil the design onto my paper and then prepare the colors that will serve as the basic color plan: a warm yellow (new gamboge and yellow ochre) to contrast with a cool blue violet, that I make with a mixture of Winsor blue and a bit of alizarin crimson. I give the board a half-turn so I can control the edges of the large sky wash where it meets the building shapes. I use my 1½-inch flat brush and paint the sky boldly and directly, carefully cutting around the edges of the buildings. After wiping excess paint away from the edge of the paper, I return the board to its normal right-side-up position. While the sky wash is still quite damp I decide the sky needs to be warmer and I brush a light value of permanent rose into the lower areas, letting it mingle with the basic sky wash. At this time I also paint the roof of the foreground shed. I now change over to my 1-inch flat brush, and with the warm yellow mixture I wash in the shapes of the center house and pine tree.

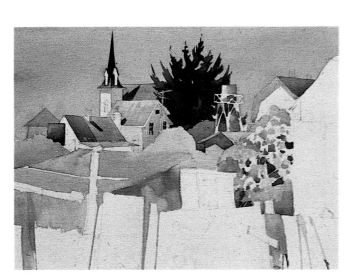

Figure 10-5.

Step 3. I continue to paint the rooftops, using warm violets for some and cool blue greens for others. Next, I paint the foliage of the flowering bush. The shapes of leaf masses are simply spots of color with plenty of white paper showing between. The light green is made with Winsor yellow and a bit of Winsor green. For the dark spots of foliage I add alizarin crimson to the Winsor green. The church spire and the dark pine tree are painted with a mix of Winsor blue and burnt umber. I charge several brushstrokes of new gamboge into the tree while it is still wet. I paint the right half of the water tank with ultramarine blue and quickly add a bit of yellow ochre to the left side, letting it blend into the blue. The orange chimney is made with new gamboge and a bit of cadmium scarlet.

Step 4. Mixtures of my basic sky color are repeated in the foreground fence. I alter the color of some boards by adding burnt sienna to the blue violet mixture. Next I paint the dark openings in the fence and shed with a mix of alizarin crimson, burnt umber, and Winsor blue, keeping these transparent and on the warm side. Darker values are added to the fence boards by dragging the side of my brush across the surface of the paper. Using very little water in the brush helps to create the rough texture of weathered wood. I paint in a few more windows and other darks, and then, with my No. 6 rigger, I add the details of the fence boards and nail holes.

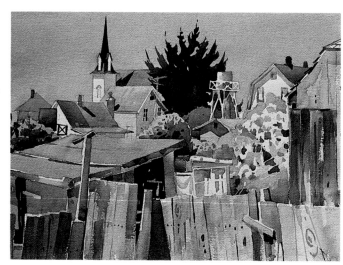

Figure 10-6.

Step 4. (Detail). The painting treatment of fence boards is shown in this detail. The boards are simply stated. Notice how the shadows help to get the feeling of sunshine. Leaving bits of white paper here and there adds sparkle.

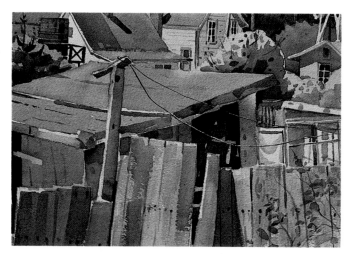

Figure 10-7.

132

Figure 10-8. Backyards, Mendocino, 18x24 inches.

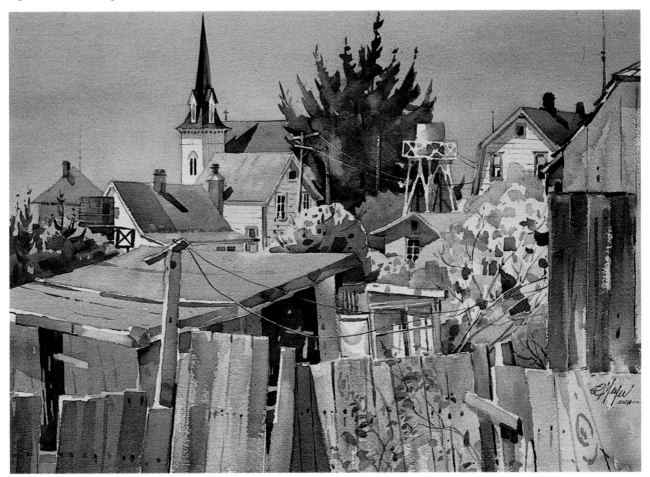

Step 5. At this stage I stop for a few minutes and study the value structure of the painting. The dark value of the pine tree seems to be overpowering, drawing attention away from more interesting elements. I dampen the surface of the tree, and after waiting for a few moments I wipe away some of the dark paint with a tissue, being careful not to disturb adjoining washes. The lighter value now pushes the tree back.

Now I proceed to add refinements and finishing touches to the rest of the picture. With my No. 6 rigger I add the clotheslines, several limbs and branches, window detail, board lines, and little accents here and there. Finally, I use a razor blade to scratch in the power lines and the clothesline where it crosses the dark opening of the shed. The picture is complete.

Demonstration 2

Boatyards

The watercolorist who paints on location must learn to be flexible, to adapt to new problems and real-life situations, and to strive for originality. It's important to try to find an uncommon or unusual viewpoint rather than to select one from a preconceived notion. Finding a viewpoint that is new and different has an emotional impact that creates a mood and stirs the imagination.

Instead of always doing boats tied up at a wharf, I enjoy painting them when they are up for repairs. The undersides of hulls often reveal exciting textures and colorations. While scouring the Marshall Boatyards on Tomales Bay for a promising subject, I was struck by the brilliance of sunlight on a group of boats up out of the water. One of the problems I faced in painting this scene was how to fit the boats into the picture area so that the composition would allow a good balancing of forms and color.

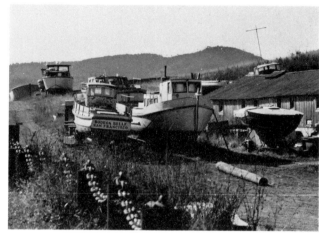

Figure 10-9.

Step 1. I decide to move in close and eliminate the distant boats and hills which, although paintable, seem to divert attention from my subject, the cluster of three boats. The shadows cast by the early morning sun are the key to my composition. They provide powerful darks that I can use to emphasize the sunlit sides of the boats. They also suggest a directional thrust into the picture.

As I sketch the compositional possibilities, I realize that I need to borrow other shapes to balance the design. One big advantage of *being there* at the site is the very real aspect of on-the-spot seeing. If an element is needed to help structure the composition I only have to turn my head and there it is. The barrels in the foreground are borrowed, as is the sign on the roof of the boat shed. Now all the shapes seem to break the composition into pleasing patterns. Although my sketch is quite rough, it does help me plan an overall value pattern for my painting.

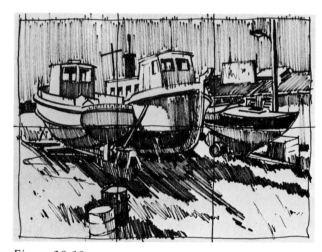

Figure 10-10.

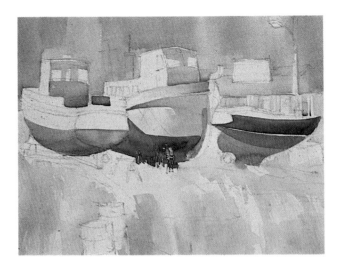

Figure 10-11.

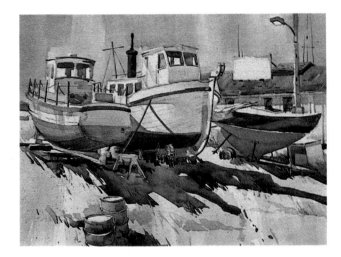

Figure 10-12.

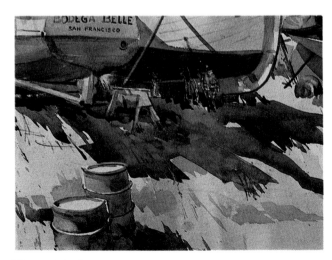

Figure 10-13.

Step 2. After I lightly pencil the outlines of my subject on the watercolor sheet, I try to see the design mentally, to fix it clearly in my mind, before I apply the first washes. In this way I'm able to save some large white shapes, which are particularly important in this subject because I want to capture the mood of a bright, sunny morning. Now, with my 1½-inch flat brush, I paint the sky area with a wash of cerulean blue and Winsor blue, stopping carefully at the white shapes. Into this wet sky wash I quickly add brushings of violet (Winsor blue and alizarin crimson). Paint is applied with broad vertical strokes and allowed to blend into the first wash.

I paint the foreground next, starting with a mixture of yellow ochre and new gamboge at the right, and continuing with a mixture of burnt sienna and Winsor violet, light in value, as I move to the left. Pieces of local color are now painted onto the boat hulls. The brilliant light on the center boat is achieved by painting this area with a mix of cerulean blue and permanent rose, and then quickly softening the edges with a second brush and clean water. The bottom of the boat at the right is painted with alizarin crimson and scarlet lake.

Step 3. The colors I use as the painting progresses are not so much part of a planned procedure as they are a reflex action to the adjustments needed in color and value. I try to force a strong contrast of values, making the lights appear lighter by placing darker darks next to them. To get light into the painting, I place a warm light against cool shadows. Shadow areas, although dark, are kept transparent by mixing the paint with plenty of water. If values start drying too light, I put in more saturated color.

The reflected light from the sky is bouncing into the cast shadows on the ground. I start painting these with a burnt umber and Winsor violet mix, and then continue with a mix of Winsor blue and alizarin crimson. Now I start adding detail of lines, posts, stacks, windows, and so on. The roof of the boat shed is painted with an interplay of violet and raw sienna. Values under the hulls are intensified.

Next I take a breather to study the total effect. The thrusting shapes of the boats and their shadows seem to lead the eye out of the left side of the picture. I will deal with this problem in Step 4.

Step 3. (Detail). This detail shows the loose, free brushwork I get with a 1½-inch bristle brush. No attempt is made to define individual pieces of grass. Instead, the edge of the brush is allowed to suggest grass and weeds. The paint in the shadow areas is dark in value but I keep it liquid to achieve transparency. A few lines are scratched into the wet paint with the corner of a razor blade.

Figure 10-14. Boats at Marshall, 18x24 inches.

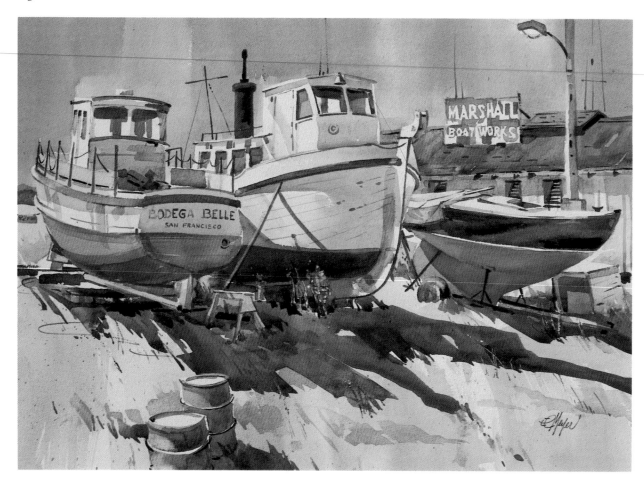

Step 4. I decide to paint the sign on the roof a bright red orange, to pull the eye away from the left side of the composition and back into the picture. I have now arrived at the final stage, where the amount of finish needs to be carefully selected. I like a loose effect and don't try to polish the surfaces too much. Sometimes if I make a painting too precise I lose what could be a more spontaneous effect. Also, an overabundance of detail can detract from the visual impact that aroused my interest in the first place. I finally add a few lines and spots such as the rafter ends on the boat shed. I paint the name on the stern of the left boat and force myself to stop at this point.

Demonstration 3
Rocks and Surf

The best way to paint rocks and surf is on location, where you can see how the waves roll and break against the headlands. To experience the sound of the surf and the smell of the salt spray is both stimulating and refreshing. I can spend hours just listening and looking.

The photograph shown here represents only a small portion of Salt Point, a section I have chosen for this demonstration. The whole coastline has picture-making possibilities that have inspired me to make numerous watercolors under varied weather conditions.

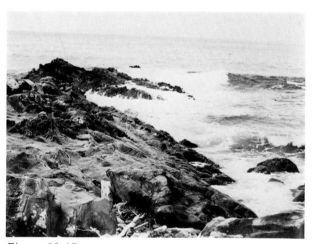
Figure 10-15.

Step 1. I don't set my easel up right away, but explore the area with my sketchbook. I make a rectangular opening in a sheet of paper and through this frame I search for a viewpoint that has a large, simple value structure.

A coastal scene can change from minute to minute and I often find it difficult to retain the first impression it makes upon me. Sometimes while I'm painting, things happen that cause me to change my original concept, such as wave actions or a receding tide revealing new forms. The wave action today is fairly repetitive and I decide to play the darks of the distant rocks against the exploding foam. The composition is based on two major shapes, rocks and ocean, embracing each other. The slanting, overlapping rock forms in the foreground lead the eye into the picture. Fortunately, there are no clouds; they would be superfluous with all the interest in this view.

Figure 10-16.

Step 2. After lightly penciling in the main shapes of rocks and wave, I dive into the painting very quickly. I first dampen the paper with clean water but try not to get it too saturated, since I'm working in the damp air along the coast. While waiting for the

Figure 10-17.

Figure 10-18.

Figure 10-19.

surface moisture to leave the paper, I prepare a dark mixture of blue-violet made with Winsor blue and alizarin crimson. I also prepare a separate mixture of blue-green (ultramarine blue and Winsor green).

The board is at a slant of 15 degrees and is momentarily turned sideways to help control the flow of the washes. I paint the large color mass of the ocean with the blue violet mixture, using my 1½-inch flat brush. I leave long white spaces here and there to indicate minor wave action.

Next I apply the dark blue-green to the undersides of the waves, modeling my touches to the direction of movement. I also charge a bit of this blue-green into a few areas of the ocean. As the paper begins to dry. I use a paper tissue to blot up color that has run into the spray and into the tops of the waves. The focal point of this picture will be the breaking wave, and I seek to retain its brilliance through the use of white paper, which is modeled with a mix of permanent rose and cerulean blue.

Step 3. I usually work fast during the first few stages of the painting because I want to establish large dark-light shapes and warm-cool color relationships as quickly as possible. To provide a warm contrast with the blue-violet water, the near headlands and beach are covered with a middle-value yellow ochre wash; lighter values go in the foreground. I soften some of the edges with a second brush, from which clean water has been squeezed. I then paint burnt sienna into several areas of the yellow ochre wash.

Next I change to my 1-inch flat brush and paint Winsor violet in different values into the rock formations, allowing the touches of the brush to contribute to their directional thrusts. I add a bit of raw sienna to the beach and to areas between the foreground rocks. I also paint the rocks in the foreground water with raw sienna, which I then model with Winsor blue and burnt sienna. As the earlier washes start to dry, I scrape in a few pieces of driftwood and small rock forms, using the edge of a cut-up credit card. I try to keep the foreground simple, with just enough interest to slow the eye.

Step 4. Now I paint the dark mass of rocks against the white spray; the contrast helps to arrest the eye here. While this area is the focal point, it nevertheless needs to be in harmony with the rest of the composition, in which minor values and shapes echo the dark mass in diminishing importance. You might say that I am building the composition in reverse. The reason is that in watercolor, unlike oils or other media, the lightest values are generally put down first, with a gradual build-up to the darks.

A mix of raw sienna and burnt sienna is painted

Figure 10-20. Salt Point, 18x24 inches.

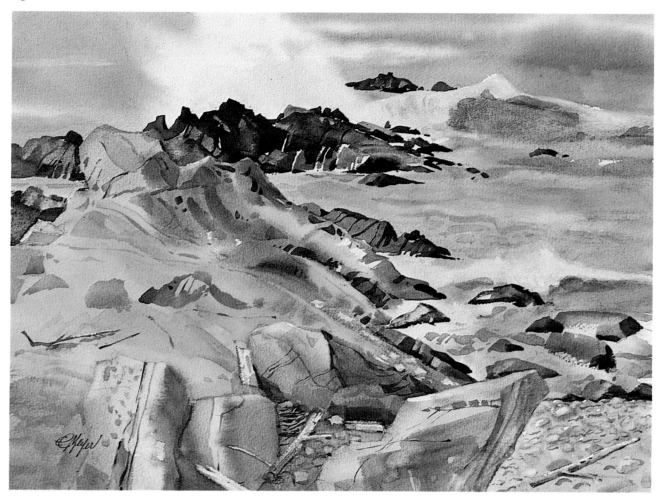

into the lower portion of the dark rock mass. As I paint this area, I stop and start the movement of my brush in order to leave white sparkles of paper where water cascades over the rocks. A deep mixture of alizarin crimson, Winsor blue, and Indian red is painted over the top portion of the rocks, allowing it to blend into previous washes. As the paint starts to dry, I scrape into it with a credit card, which exposes the alizarin crimson, a staining color that has sunk into the paper. A few other rock forms, at the upper right and upper left, are added with raw sienna with mixtures of Winsor and alizarin crimson.

Step 5. The last stages of the painting require a slow finish. Going too fast at this point can cause an overworking. I can easily go too far and then it's too late—I can't go back. After studying the painting, I decide to add a few calligraphic lines to indicate the cracks and crevices in the rocks. These are fun to do, so I always have to be careful not to overdo it. I grasp my No. 6 rigger near the end of the handle and allow it to dance along freely. The small, free-flowing lines animate the picture surface and help to describe the rock forms. At this time I also add the shadow sides to the driftwood and to the rocks and pebbles on the beach.

Demonstration 4
Play of Sunlight

The abundance of material that confronts you when you go outdoors to paint is often quite confusing. To organize this turmoil, it helps to see the subject strictly in terms of design, selecting those things that will serve to build a vigorous composition and discarding all else. The elements must be right if the picture's going to work. The more decorative the arrangements of these elements and the more striking the pattern, then the better the painting. The grouping of old buildings shown in the photograph would have been an unlikely subject were it not for the play of sunlight, which transformed the shapes of the buildings into strong, alternating patterns of positive and negative shapes.

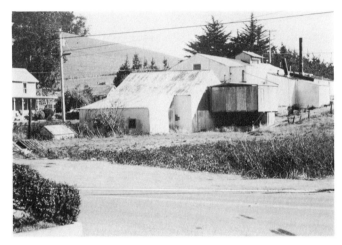

Figure 10-21.

Step 1. To pretest the picture-making qualities of these shapes, I make a sketch with felt-tip pens. Middle value passages are put down first. Ideal for these are pens that have nearly exhausted their ink supply. Dark shapes are then sought out and added with a pen that has plenty of fluid. I use a fine-line pen at the end to define edges, shapes, and detail. Sketching with felt-tip pens in this manner is fast and uncomplicated. This sketch establishes a creative concept, in which leaning shapes move back into space, up and down, horizontally and diagonally. Having worked out the major problems of composition and values in advance, I am free to concentrate on color and on fresh, clear washes.

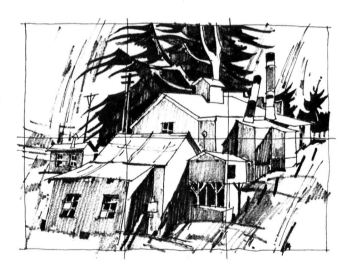

Figure 10-22.

140

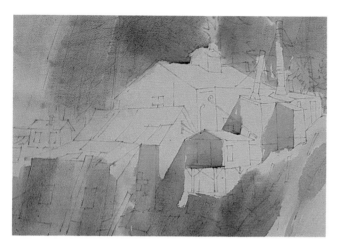

Figure 10-23.

Step 2. While penciling my composition onto the watercolor sheet, I visualize how I am going to approach the application of washes and how the completed painting will look. I select a simplified color scheme of a few warm colors (burnt sienna, burnt umber, yellow ochre, and alizarin crimson) and a few cool ones (Winsor blue, manganese blue, and Winsor violet) with which to start the painting. The paper is dampened slightly and then I brush in an underpainting of cool values of Winsor blue with my 1½-inch flat brush. Paper whites are an important part of the design. I choose them before I start to paint and avoid covering them with my initial washes.

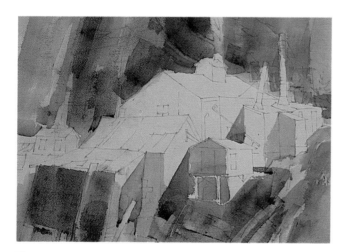

Figure 10-24.

Step 3. To get some arbitrary color changes, I continue quickly with the large brush and add mixtures of burnt umber and Winsor violet, charging these right into the first wash while it is still quite wet. To unify the design, I repeat some foreground color in the sky. A few values are also intensified with minglings of violet and burnt sienna. Next, I paint the shadows cast by projecting walls. For this I use a mix of Winsor blue and alizarin crimson. At this point the whites have been isolated and the subject begins to emerge.

Texture is scraped into the foreground as it starts to dry. Again, timing is important. If you scrape too soon, the wet color will run into the scraped lines and cause them to become darker than the surrounding wash. If you wait too long, the scraping will have little or no effect.

Step 4. The rusted tin roof of the near building is painted with mixtures of Indian red and scarlet lake. (Indian red is opaque and I sometimes mix it with the more transparent reds to subdue their brilliance.) Texture is added to the roof with a few scrapings and blottings. The roof color is echoed in the two metal chimneys, which are painted with the same rusty colors. Sunlight, bouncing from the tin roof, casts a warm glow onto the wall behind it. I paint this wall with a light wash of manganese blue and alizarin crimson. While this wash is still quite wet I quickly charge yellow ochre into it to give a feeling of reflected sunlight.

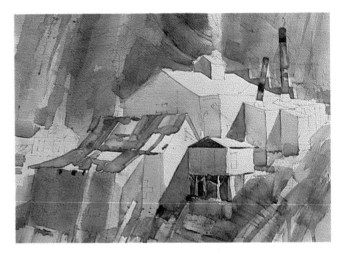

Figure 10-25.

Step 5. To add a strong value contrast, I paint the cypress tree with a rich, dark mixture of Winsor blue, burnt umber, and alizarin crimson. This dark value acts as a foil for the more transparent washes of the building shapes and makes them seem even more transparent by comparison. No green is used in the tree but it's implied by the contrast of the red roof and the red chimneys. The picture surface is enhanced by a patchwork of brushstrokes, applied with one tempo throughout. I don't polish the surface too much, but let the brushstrokes show their marks to impart a more painterly quality to the work. I go back into the tree and building shapes and model them with darker values.

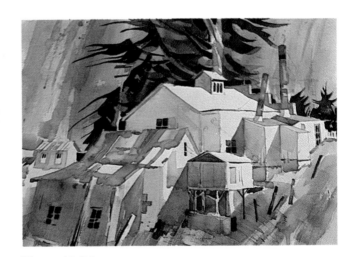

Figure 10-26.

142

Figure 10-27.

Step 6. (Tree Detail). This close-up view shows how I simplify detail by applying color with large flat brushes. This also helps to give vitality and liveliness to the surfaces. I keep descriptive lines from being dull by varying their widths. Linear brushwork gives the painting extra strength and a certain rhythm because of the use of repeating line.

Figure 10-28.

Step 6. (Foreground Detail). This enlarged section shows the broad treatment and design of shapes. As more detail is added, it is handled with the simplest technique. The emphasis is on design and the relationship of various parts of the painting to each other.

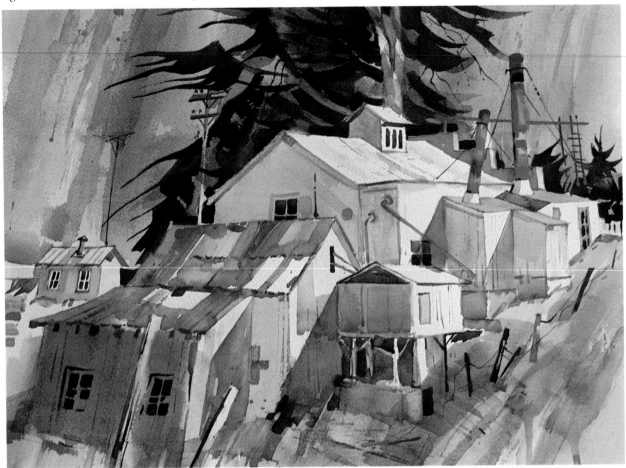

Step 6. At this point I feel the painting is completed. By placing the picture in a mat, I am able to study it carefully, to see where finishing touches are needed. I add a few lines and accents such as the TV antenna and the guy wires for the chimneys. The actual subject has much more detail than I've chosen to show, but painting it would only have cluttered the design and lessened the impact of sunlight and the movement of light weaving through the composition.

ELEVEN

Back in the Studio

The Finishing Touch

Knowing when to stop is difficult. In watercolor painting there is a point of no return, and I have found it is better to stop too soon rather than too late. Generally speaking, I spend no more than three hours—usually much less—on location on any single picture, but sometimes I can spend several more hours back in the studio, adjusting values and correcting minor mistakes. However, my usual routine is to bring a painting to near-completion at the site (if the light and the weather are willing) and to leave only finishing touches, if any are needed, for studio analysis. Work that I finish on location is usually fresher and more truthful.

Some of my watercolors never do get finished and are stacked in various places in my studio. I look at them every now and then and try to see what they need to bring them to life. Reviewing unfinished paintings (especially those that have gone wrong) often provides answers to technical problems, and clues me in on things to avoid in future paintings.

Making Changes and Corrections

I have found it's not a good idea to make changes and corrections hurriedly. Sometimes a painting is better when left unfinished for a few days or even a few weeks. Then, when I see it with a fresh eye, I more readily spot the problem areas.

Quite often I discover my lights and darks are too scattered. When this happens, I glaze over some of the lights with transparent washes. Areas that are too dark are lightened by moistening the color with a brush and clean water and then wiping the area with a tissue, repeating the process until I get the correct value.

If I desire to remove color but want a sharp edge to show, I protect the area I want to save with one or more index cards. I hold the cards firmly in place with one hand while using the other to moisten and remove color. Templates with various angles, curves, or openings can be cut from index cards or from a piece of clear acetate. You can also use templates to add color by spattering paint from a toothbrush, either against the template edge or through an opening in it. Designs and patterns can be repeated in a variety of places on the watercolor paper, for example, by pressing different colors through leaf-shaped openings with a small sponge. Colors should not be too wet or they will crawl on the paper beyond the openings. (Try the color first on a scrap of paper to make sure it is of the right consistency.)

Edges can be softened with a small bristle brush and water. Dip the brush in clean water, apply it to the edge, and carefully loosen the paint by agitating it with the brush; then wipe the area with a tissue. Repeat the process until you obtain the desired effect.

To indicate poles, tree limbs, branches, pieces of grass, or other thin lines in a *dark* area, paint the desired line or shape with clean water, wait a few moments for the water to absorb the paint, and then dab up the moistened area with a tissue.

Large areas of color can be removed by completely submerging the painting under several inches of water in a flat pan or in your bathtub. Unwanted areas, or areas to be lightened, are then carefully agitated with a bristle brush. Paint that has not been scrubbed will remain unchanged. The paper should then be stretched onto a board and allowed to dry without further disturbance. After the paper has completely dried, correct color and shapes can be painted on the sheet. Getting paper back to its original whiteness is nearly impossible and really not necessary, as new washes will cover up or camouflage images that remain.

Common Mistakes

Not making use of enough variety in any one color. Greens, especially, benefit from variety rather than the use of the same monotonous hue throughout.

Working too long on a painting. A watercolor can easily be overdone and overstated. Paint quality loses freshness and luminosity through overworking; this is especially likely to happen when you change direction in the middle of a wash. Instead, continue the wash and after it has dried lay a new wash over it.

Chasing shadows. It is important to adhere to your original concept as the sun creeps around your subject. This is where a quick preliminary sketch is helpful; it serves to nail down the shadows. Shadow lines can also be lightly drawn on the watercolor sheet.

Trying to say too much in one picture. Be consistent and stick to one theme or point; otherwise you run the risk of ending up with complex confusion that says nothing.

Losing the light. This happens when values are monotonously lacking in contrast. Remember that attention can be centered on selected areas by placing the darkest darks next to the lightest lights.

Overusing textural devices. The mere salting, scraping, stamping, and imprinting of textures becomes boring unless the painting has a sound, meaningful composition.

Using too many colors in one painting. Don't use more colors than you need, especially in backgrounds. Neutral backgrounds will allow carefully selected warm and cool colors to express themselves more fully.

How to Critique Your Own Work

Once you're able to control the fundamentals of watercolor painting, you're in a position to critique your own work. It becomes relatively easy to spot inaccuracies or deficiencies. You'll also be able to see if your painting is convincing, from both the representational and expressive points of view.

To qualify as a critic of your own pictures, you need to learn all you can about art, both past and present. You also need to become familiar with all art styles. This will give you the perspective you require to see if your picture makes a clear statement, and whether it is painted simply and forcefully.

Consider yourself fortunate when your paintings are up for a critique in a painting class or workshop. Much can be gained through visual comparison as well as from judicious comments about the composition, color, and technique of your work along with that of others. Don't let criticism upset you. It's all a part of the learning process. Art is a continuing, lifelong learning experience. The competent instructor not only seeks out the good qualities of a painting but points out ways for improvement.

Figure 11-1. Value sketch of boats at Belvedere.

The Critique

Here are some useful questions for critiquing your watercolors (or those of others):

Are darks and lights well balanced and distributed, with pleasing intervals?

Is the paint luminous in both darks and lights?

Does the silhouette of a shape (dark against light and light against dark) reveal its character and function?

Are shapes displayed in a variety of sizes and spacing?

Are shapes related to one another with an interesting interlacing or locking together?

Is outdoor light suggested with an interplay of warm and cool colors?

Are wet blendings used to give the painting a watercolor quality?

Is the point of interest repeated in other parts of the picture in a diffused or less emphatic manner?

Is movement created through direction and overlapping of elements?

Are the marks of the brush visible in repeating rhythms?

Does the use of calligraphy help to unify and enrich wash shapes?

Has texture been used judiciously?

Are figures simply stated with attention to gesture?

Did the artist stop in time or is the painting overworked?

The Camera As an Aid

Photographs can be of immense help to the painter. They can also destroy any creativeness if used literally. Copying minutely the color and detail of a photograph can best be done by sending the negative to Kodak. Nevertheless, a great number of artists work from photographs, and many do so with imagination and effectiveness. Those who have the greatest success arm themselves with photos of the motif or subject shot from many angles. Useful also are views of nearby elements that can be incorporated into the design if the composition demands it.

Working from photographs leaves much to be desired. Unless you design your composition with an inventive attitude, you are merely copying a prearranged composition, leaving nothing out and putting nothing in.

An artist with years of on-location painting experience uses a photograph as a jumping-off place and then proceeds to make a number of compositional sketches, from which the best one is selected. The photographs are put aside and the sketch used as a guide in making the watercolor painting.

The greatest advantage in using photographs is that you can gather a number of scenes and views in a short period of time. This can be particularly helpful when there isn't time to sketch all the material you'd like to bring back to the studio. A combination of both sketches and photographs is better than just photographs as you can refer to the sketches for creative ideas and to the photographs for facts and detail if needed.

The big disadvantage in working from photographs is that the important element of selection and rejection may be overlooked. You are apt to include only those things visible in the photograph when structuring your composition.

If your paintings are derived from photos, it is beneficial to work from black and white prints. This way you are not influenced by the colors of a slide or color print, which seldom reflect the true color of the subject. You are free to organize your own color harmony. This is likely to result in a more pleasing mood and a more powerful design.

Titles

Titles can unlock the purpose of your painting. They can be informative, can give a new meaning, can open the door for the viewer—but they can also drive a wedge between the viewer and your work. This sometimes happens with long titles or with strange titles that have no bearing on the substance of the painting.

Mats

A watercolor cannot be viewed properly without a mat. The mat separates the painting from its surroundings and is an important part of the composition. It also separates the painting from the glass and keeps it away from moisture that may condense on the inside of the glass.

White or off-white mats are preferable to garish colors, which may detract from the painting. Mat sizes should be standardized (2-inch increments) to fit standard frame and glass sizes. The sizes used mostly are:

22x28 inches (28x44-inch matboard cut in half) with an opening for half-sheet watercolor paper (15x22 inches).

24x30 inches with an opening for 18x24-inch papers.

28x36 inches with an opening for full-sheet papers (22x30 inches).

Margins of mats vary from 3½ inches to 4 inches. To give the painting visual stability, the bottom margin is slightly larger than the top and sides. A double mat is used quite often and is very effective. The inner mat, usually of darker value, extends inward about a quarter of an inch from the opening of the outer mat. To give the effect of a double matting, a thin line can be drawn around the opening with a ruling pen and the desired color.

The watercolor painting should lap behind the opening about ⅜ of an inch all around and be secured, at the top edge only, with several 2-inch-wide hinges of adhesive-backed acid-free linen tape. The sides and bottom of the painting may be temporarily secured to the back of the mat with small pieces of cloth tape. These pieces should be removed when the painting is placed in a frame, to allow the painting to expand or contract.

Trial Mats

A mat should be placed on the work from time to time as the work progresses. A convenient folding mat to take along on painting trips can be made by cutting a mat in the center, as shown, and affixing cloth tape hinges to the back.

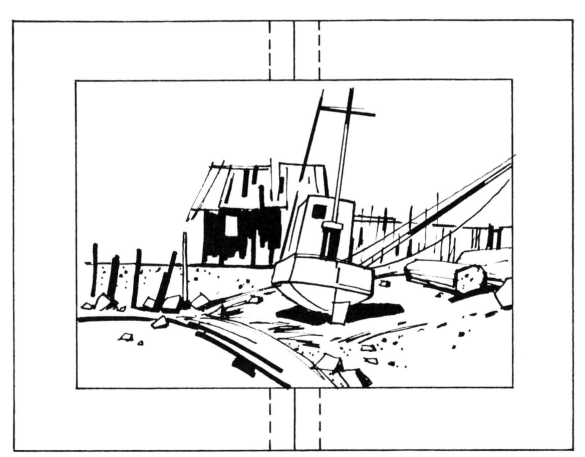

Figure 11-2. Folding mat.

Figure 11-3. Finder mat.

Finder Mats

When a painting has become overworked or is too busy, with an overabundance of subject matter, often a section of it may be worth saving. To preview acceptable portions, a finder mat consisting of two L-shaped pieces, cut from a discarded mat, can be moved around the painting. A final mat with the desired opening can then be cut.

Cutting the Mat

A mat cutter to fit your needs can be selected from a variety of cutters on the market. With a little practice mats are relatively easy to cut and just a minimum of equipment is required. It's important to have a metal straightedge, one that will reach across the long side of a standard sheet of matboard (32x40 inches). A 42-inch straightedge is ideal. To keep the straightedge from slipping, nail a small block of wood to the top front and another to

the bottom front of a plywood board or matting table (Figure 11-4).

The first step is to lightly draw in your pencil guidelines for the picture window. The bevel-edged window is cut with a Dexter Mat Cutter. Mats are generally cut from the back but can also be cut from the front. When cutting from the front, the pencil guidelines are easy to erase if lightly drawn. The cutter blade is adjusted to point inward when cutting from the front and outward when cutting from the back. Insert the point of the blade into the matboard at the starting point of the pencil line and then position both cutter and mat against the straightedge. The cutter is pushed along the straightedge with one hand while the mat is held firmly in place by pressing down on the straightedge with the other hand. A scrap of matboard under the cutting area makes cutting easier and will prolong the sharpness of the blade.

Framing

While the choice of frames is seemingly endless, most watercolors look best in narrow, sturdy hardwood frames. Metal section frames are also widely used; they are less expensive, easily assembled and available in a wide choice of colors. The silver finish is often preferred, as it relates the painting to a variety of surroundings most successfully. Metal frames are discouraged in some exhibitions because of the danger of glass breakage. This is caused by the impact of glass against metal when frames are set down sharply on concrete or hardwood floors. Acrylic glazing eliminates this problem, although it is quite expensive. When shipping a painting, acrylic glazing is required, regardless of whether the frame is wood or metal.

There is a great concern today with conservation matting and framing, to protect artwork against the possibiity of acid damage. This necessitates the use of acid-free materials in the mat, the backing, and tape with which the painting is secured to the back of the mat. Naturally, the use of such materials increases the cost of framing. To help conserve the painting in regular framing, a barrier of aluminum foil or mylar should be placed between the painting and the backing. The backing can also be sealed with a coat of acrylic paint. With wood frames, the space between backing and frame needs to be sealed with paper or cloth tape.

Figure 11-4. Mat-cutting equipment.

Dos and Don'ts

Here is a list of a few important dos and don'ts, some of which I have already mentioned.

Always get permission before painting on private property. Most people are pleased to grant it.

Respect private and public property. Obey "No Trespassing" signs and don't leave a mess of tissue papers, lunch bags, or other trash.

Count your brushes before leaving a painting site. Brushes, if accidentally dropped, don't like to be stepped on and instinctively find a good hiding place, in tall grass especially.

Spread a plastic sheet under your easel when painting on a wharf or boardwalk. Dropped brushes can easily slip through the cracks between planks.

Paint with groups or with several painting companions. Not only will you have more fun but you will be secure. Painting with others will get you into new territory and expand your horizons.

Don't leave your gear unattended when you take a coffee break. Have a member of your group keep an eye on it.

Don't leave your painting on the ground or leaning against a fence, where friendly dogs are apt to critique it.

Don't always try to paint a masterpiece. Relax. Swing a big brush and let the drips run where they may.

Use your eyes more than your brush. Try to be more inventive and be willing to experiment.

Try to paint with your paper in shade. It's difficult to see color and value correctly if the sun is shining directly on your picture. Some artists like to paint in bright sunlight because it forces values. When there is no shade, the board can be tipped up to a nearly vertical position away from the sun.

Don't set up your easel on busy roads or near busy intersections where interested spectators are likely to stop and hinder the flow of traffic.

Try painting your subject against the light. You will see more large silhouettes and less picky detail.

On a windy day you can usually find a quiet spot on the lee side of some object or barrier.

Dress comfortably. If you plan to drive out to paint on a cold or windy day, take along an extra sweater or jacket. It seems unnecessary to mention this, yet I've seen artists nearly freeze to death because they misjudged the weather. On the other hand, there are times when you can get a sunburn, even on overcast summer days, unless you have wisely brought along a wide-brimmed hat, just in case. Your attire should be the kind that can take a few paint splashes. Good hiking shoes are a must if you plan to scramble around over rocks or rough terrain.

Develop good painting habits. Use clean water. Change the water frequently. Painting with dirty water is often the cause of a muddy painting.

If you plan to paint along the coast, get there early before the wind starts up.

Sunday mornings are the best times to paint city street scenes. Streets in commercial districts are especially quiet on weekends.

Don't leave cameras, purses, or other valuables in plain view in your car, even if it is locked. Place them in the trunk or where they can't be seen. Better yet, take them with you.

Squint when you study your subject.

At the end of the year, take a good look at your work and see where you are going. Go back and paint the same subjects and try to see them in a new light and with a fresh eye.

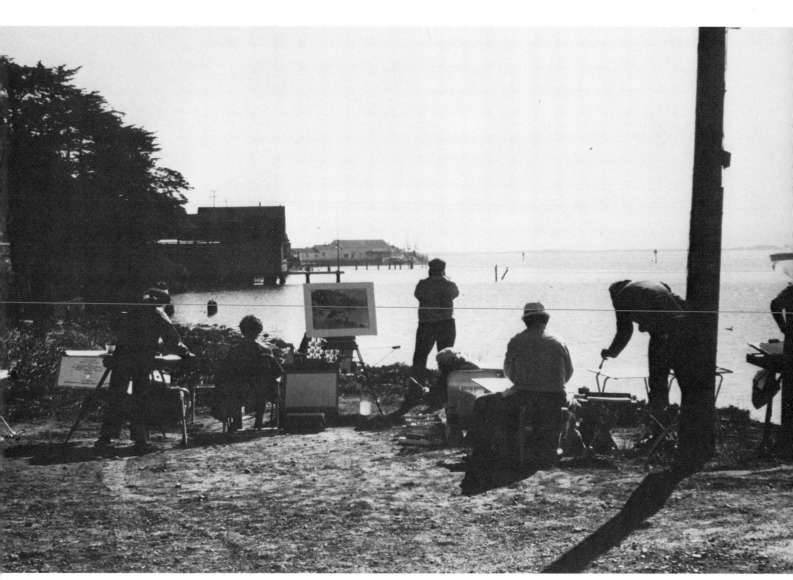

Figure 11-5. On-location workshop at Bodega Bay.

Keep Painting!

Throughout this book I have stressed the need to get light into your picture. One sure way to do this is to remember to save some of that white paper. Light doesn't always depend on white paper, however, but can also be expressed by the contrast of darks next to the lighter values. The thing to remember is that you can't have light without dark. It's equally important—and I can't remind you often enough—not to overwork a painting. This can result in losing brilliant passages which are vital to putting life into a painting.

It often happens that you lose the light and everything seems hopeless. This is the point when many painters give up and start over. But you might just keep going. You can learn more through struggle than you can when everything falls into place right away. Sponge out the muddy darks and let the paper dry. Then come back in with clean, transparent washes and a few accents.

Painting on location on a regular basis can rapidly improve your painting skills. Painting with groups or with one or more painting companions increases the challenge and broadens your viewpoint. By taking turns in selecting painting sites, you are forced to deal with new subject matter and with new problems. You are pushed out of old habits and into new territory.

Take a serious look at what other artists are doing and at their painting methods. The variety, novelty, richness, and creativeness of each artist enlarges your horizons and moves you on toward a new way of seeing. Painting is a continuing learning process and there is *no one way* to paint a watercolor. It always amazes me to see a group of watercolorists painting the same subject, yet no two paintings are ever alike. Each artist presents an individual viewpoint, different from everyone else's. This is what makes art so exciting.

Learn all you can about this wonderful medium, about composition and technique, and then go out and be yourself. Don't try to paint a masterpiece or try to imitate another artist's style. Whenever you go out to paint, just try to have some fun, be inventive, and take a chance. Most important, learn to *see*. Painting, as I have said, is an adventure in *discovery and selection*.

If you can see the important value changes that contribute so much to the design of a composition you're well on your way. Punch out a few darks next to the lights where they count most, and watch your work spring to life. Remember, too, values are more important than color. If the values aren't right, color won't save the painting. When you have both correct values and correct color, your work will stand up there with the best. Don't get discouraged if your work doesn't meet with your expectations. Find out what you are doing wrong and then try not to continue making the same mistakes.

I hope that, if you follow the suggestions in this book, you will have a greater understanding and awareness of the techniques and mechanics of watercolor painting and that they will add richness of color and luminosity to your work.

Keep painting!

Exhibitions

Seeing your work alongside that of others will allow a just comparison and fair appraisal of your painting efforts. Deficiencies that you hadn't noticed in your studio suddenly reveal themselves. Improvement comes only by continuing to *see* and *do* and never stops with honors and awards.

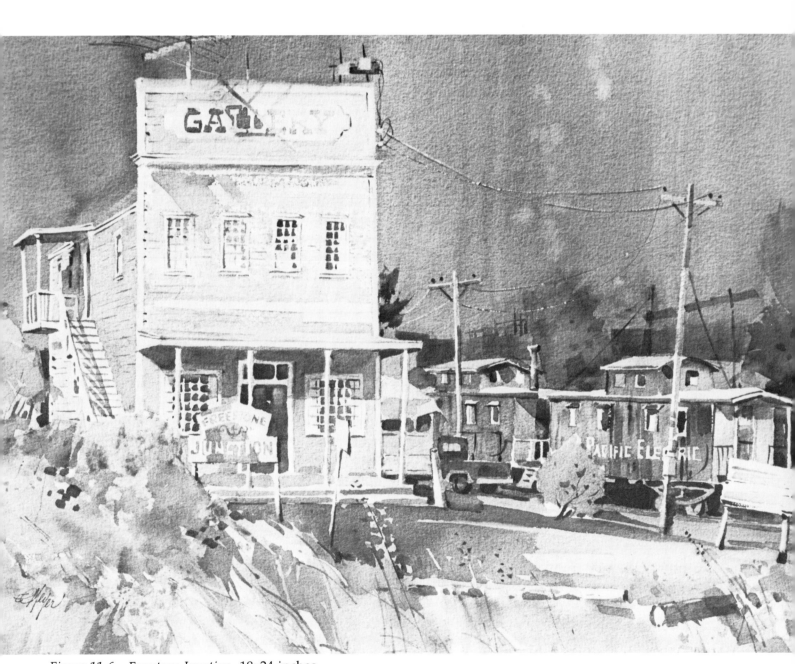

Figure 11-6. Freestone Junction, 18x24 inches.

Figure 11-7.
This view shows the work area at the north end of my
12x24-foot studio. Here, surrounding my drawing table,
are shelves and drawers to hold paints, papers and other
art supplies. Completed works are displayed in a gallery
area at the south end of my studio.

Working Indoors

Hundreds of sketches and drawings, made on location, are stacked away in my studio, where I occasionally find time to distill and combine the more promising ones into creative, meaningful statements. While indoor work seldom captures the vitality of the original outdoor sketch, it does provide a time for the discipline necessary to bring about an orderly display of colors and shapes. Quite often these studio searchings find their way into later on-location work.

Painting Terminology

Calligraphic lines are expressive, free-flowing lines, spontaneously drawn, usually with a brush that has extra-long hairs, such as a script liner or rigger.

Drips and runs are the result of dripping water from your fingers or from a large brush onto a wash before it has dried. The amount of water and the slant of the paper determine the effect.

Edge stamping is done by applying paint with the edges of matboard scraps. It is useful for indicating boat masts, telephone poles, posts, picket fences, and the like. Edge stamping can also be used for quickly blocking in subject matter, usually with ochres and umbers.

Glazing is the process of applying a second or third wash over an underlying wash that is completely dry.

Graded washes are made by gradually moving from dark to light or from light to dark as you paint.

Hard edges result when painting directly on dry paper. To paint overlapping shapes with hard edges, the underlying washes must be dry.

Lift-offs are accomplished by lifting color with a brush from which water has been squeezed, or by wetting a painted area and immediately wiping it with a tissue or a paper towel. Lift-offs can be controlled by using stencils cut out of clear plastic sheets or by protecting areas with index cards or masking tape.

Light is created by surrounding an area with a darker tone.

Lost-and-found quality is a quality of painting that occasionally allows parts of the subject to dissolve or fade away into adjoining washes and then reappear at intervals.

Masking is done by protecting paper whites or previous washes with a masking liquid (available from various manufacturers), or with masking tape, cardboard, or other material. Masking solutions and tape are removed after washes have completely dried. Masking liquids are nonstaining and are easily removed by rubbing off with the fingers or an eraser.

Negative shapes are the spaces between and around positive shapes.

Positive shapes are the shapes of objects themselves.

Salt, when thrown into a wet wash, can create surprising textures, usually in the form of tiny stars or white flecks. The texture varies according to the wetness of the wash or the slant of the board. The salt can be brushed away after the washes have dried completely.

Scraping is done with various tools such as brush handles, knives, razors, plastic credit cards, etc.

Silhouettes are shapes without interior detail.

Spatter is done by dripping or flicking color from a loaded brush or from the fingers, or by tapping a smaller brush loaded with thicker color against a pencil or other firm object.

Textures can be created by applying paint with sponges, burlap, wire screens, paper towels, and similar material. These textures reveal themselves in rewarding ways when transparent washes are applied over them after they have dried.

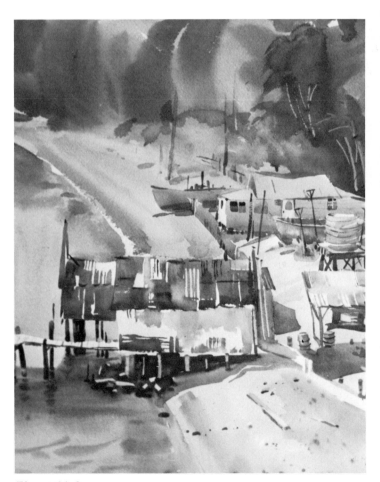

Figure 11-8.
China Camp, 22x30 inches.

Bibliography

Betts, Edward. *Master Class in Watercolor.* New York; Watson-Guptill Publications, 1975

Brandt, Rex. *Watercolor Landscape.* New York: Reinhold Publishing Corporation, 1963

The Winning Ways of Watercolor. New York: Van Nostrand Reinhold Company, 1973

Brooks, Leonard. *The Many Ways of Water and Color.* Westport: North Light Publishing, 1977

Carlson, John F. *Carlson's Guide to Landscape Painting.* New York: Dover Publications, 1960

Hawthorne, Mrs. Charles W. (Collected by). *Hawthorne on Painting.* New York: Dover Publications, 1960

Loran, Erle. *Cézanne's Composition.* Berkeley and Los Angeles: University of California Press, 1970

Pellew, John C. *Painting in Watercolor.* New York: Watson-Guptill Publications, 1970

Reid, Charles. *Figure Painting in Watercolor.* New York: Watson-Guptill Publications, 1972.

Reynolds, Graham. *A Concise History of Watercolors.* New York: Harry N. Abrams, Inc., 1971

Sloan, John. *Gist of Art.* New York: Dover Publications, 1977

Whitney, Edgar A. *Complete Guide to Watercolor Painting.* New York: Watson-Guptill Publications, 1974

Wood, Robert E. *Watercolor Workshop.* New York: Watson-Guptill Publications, 1974

Index

117; from memory, 26; nature's inspiration for, 9, 11, 56; and onlookers, 58, 117; packing equipment for, 115 (*see also* Equipment and materials); precarious situations in, 63; preliminary sketches for, 14, 40, 63 (*see also* Sketching); procedures for, 14, 138 (*see also* Demonstrations); seeing essentials of, 11, 13, 56, 60, 62, 68, 106 (*see also* Composition; Mood; Subject matter); universal concepts in, 14; viewfinding for, 71, 137. See also Colors; Landscape elements; Techniques for variety; Washes

Paints. *See* Colors

Palette: arrangement of colors on, 83; Eldajon, 33, 34, 83; keeping paints moist on, 32, 50; limited, 92; O'Hara, 34; Pike, 33, 34. *See also* Colors

Paper: keeping moist, 32; preparing for painting, 36-37; for sketching, 40; slant of, in painting, 50; splashed at random, 46; types of, 36, 50

Paper whites: as elements of painting, 14, 20, 45, 46, 94, 95, 115, 141, 154; left dry, 46; saved with masking liquid, 46, 91, 157

Perspective. *See* Composition

Photographs: black and white preferred, 148; with demonstrations, 128-43; working from, 113, 148

Planes, overlapping. *See* Depth

Positive and negative shapes. *See* Light and dark

Shadows. *See* Landscape elements

Silhouettes, 157

Sketching: charcoal, 42, 43, 127; chisel-tip pen, 43; felt-tip, 22, 26, 27, 40, 42, 140; with a grid, 63; indoors, 120, 123; lampblack, 42; outdoors, 120-21, 122; Pentel pen, 106; from photographs, 148; schematic, 25; sketchbooks and paper, 40; thumbnail, 26; values established in, 20, 42-43, 75 (*see also* Light and dark); wash, 42. See also Demonstrations; Figure, human; Subject matter

Subject matter: boats and waterfronts, 105, 115, 129, 134; buildings, 110-12, 115, 131, 140; close to home, 59; close-ups, 109, 134; driftwood, 102, 138-39; interpretations of, 12-13, 18-19, 55, 106 (*see also* Demonstrations); on private property, 57, 117; rural scenes, 108; in scenic parks, 56, 116; towns and cities, 112-13, 116, 133. *See also* Figure, human; Landscape elements

Surface interest: footprints in sand, 41; on painting (*see* Techniques for variety); of subject, 21

Techniques for variety: applying paint with various objects, 14, 46, 145; calligraphic lines, 14, 18, 23, 101, 139, 157; creasing wet paper, 14; drips and runs, 14, 19, 45, 157; dry brush, 45, 46, 49, 131 (*see also* Brushes); hard edges, 21, 157; lift-offs of color, 14, 20, 45, 46, 157; overusing, 146; razor blade scratching, 105; sandpapering, 14; scraping into wet paint, 17, 19, 39, 45, 46, 50, 53, 90, 101, 108, 141, 157; spattering paint, 45, 46, 145, 157; stamping, 45, 46, 52, 157; stenciling repeat motif, 145; "superficial tricks," 9; template shapes, 46, 145; throwing salt on wet color, 14, 45, 46, 90, 157; varied washes (*see* Washes); wet-into-wet, 21, 33, 45, 49, 83, 89, 97. *See also* Colors

Textures. *See* Techniques for variety

Titles for paintings, 148

Trees. *See* Landscape elements

Values: selection and distribution of, 9, 14, 20, 64, 66, 80, 88, 133, 154; in sketches, 20, 42-43, 75. *See also* Light and dark

Washes: blending, 45, 49; controlled, 45, 97; graded, 157; handling for luminosity, 46; preliminary, 90; sketching with, 42. See Demonstrations; Glazes. *See also descriptions of illustrations*

Watercolor medium: controlling, 13, 90, 100; effect of damp weather on, 100; happy accidents with, 14; luminosity of, 9, 14, 46, 90, 94; virtues of, 9, 13, 46, 97. *See also* Colors; Glazes; Washes

Wet-into-wet. *See* Demonstrations; Techniques for variety